A COLORING BOOK

MANDALAS
— ESSENTIAL —

BY LUCAS BONFANTE

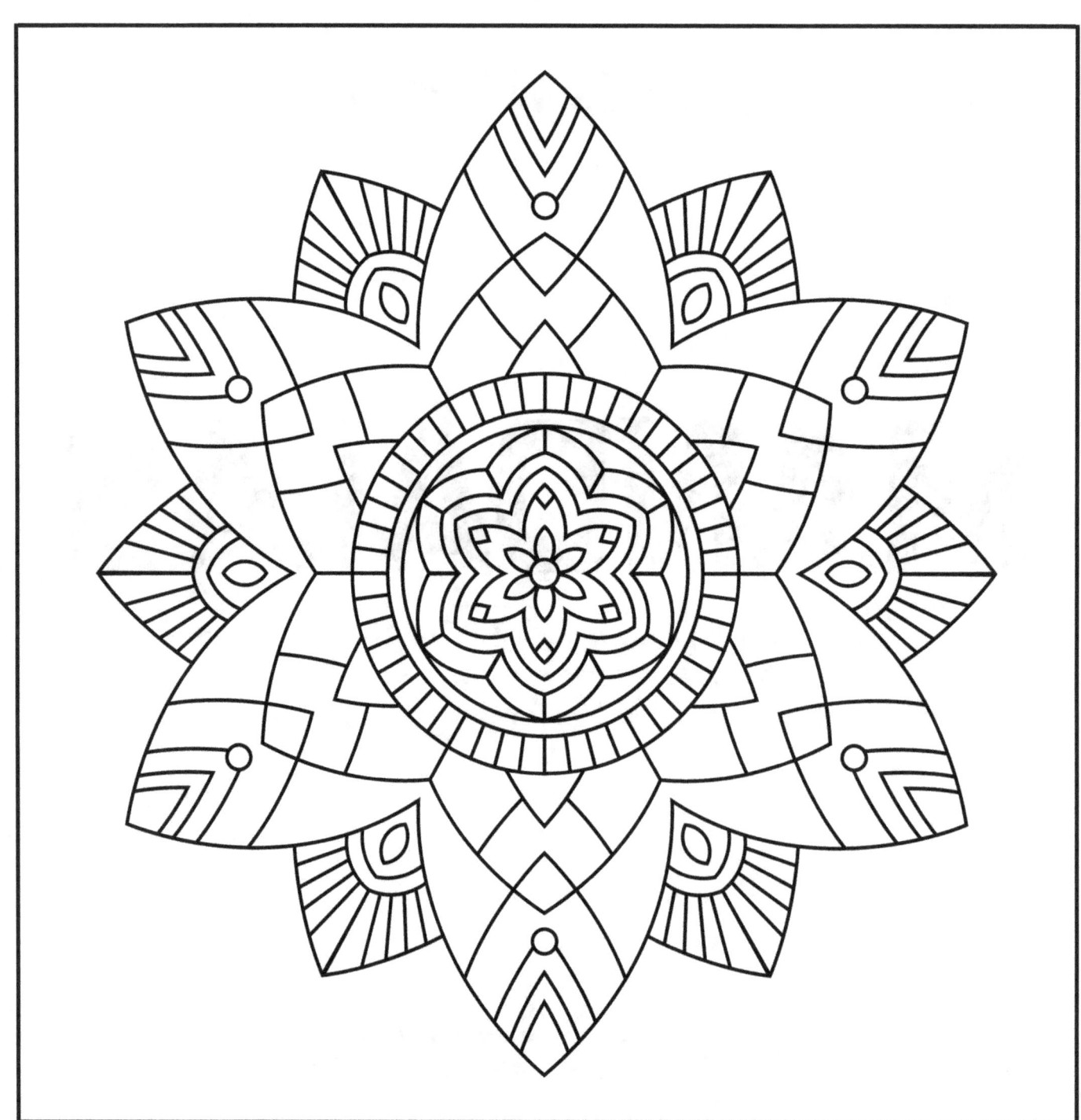

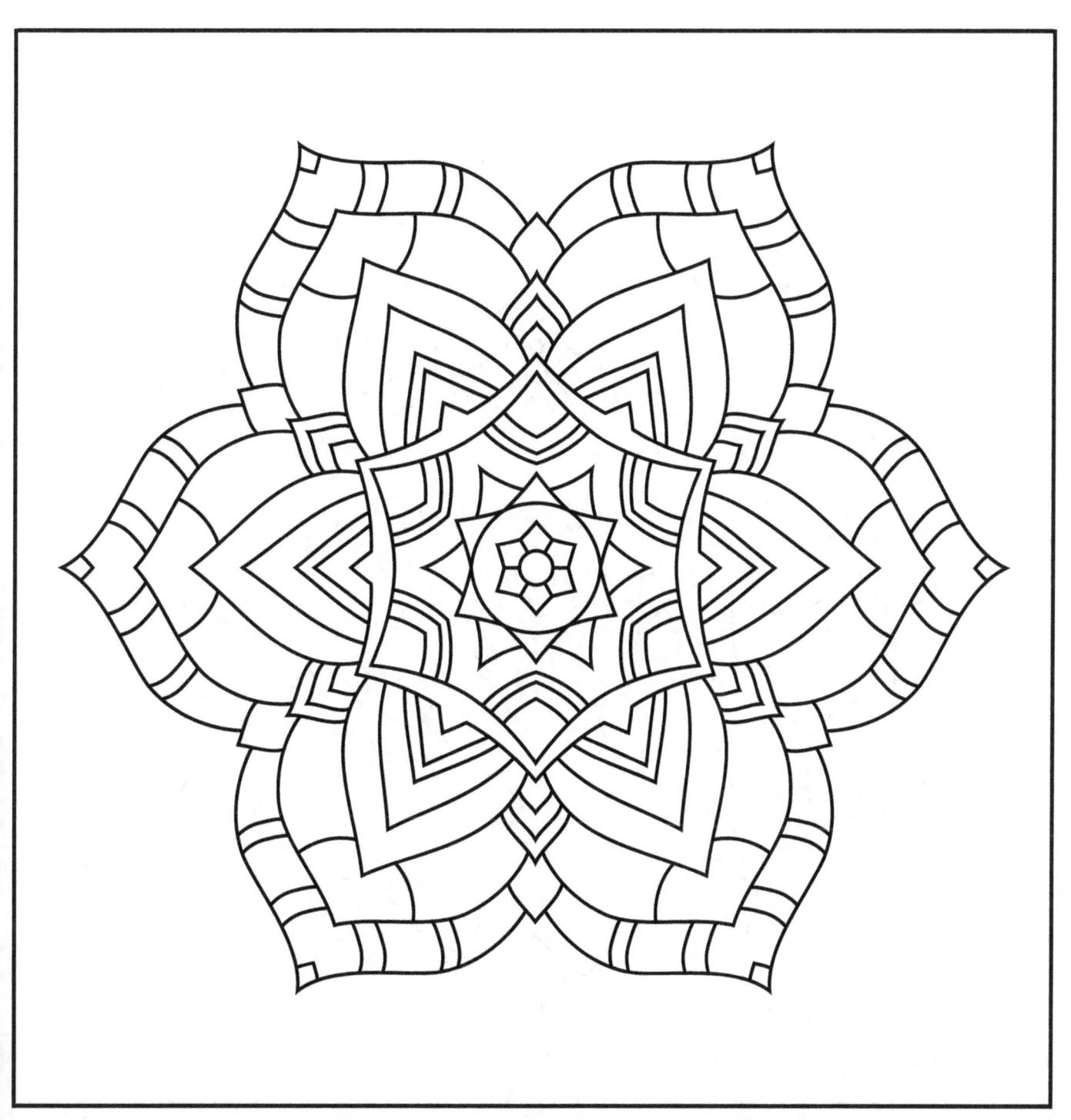

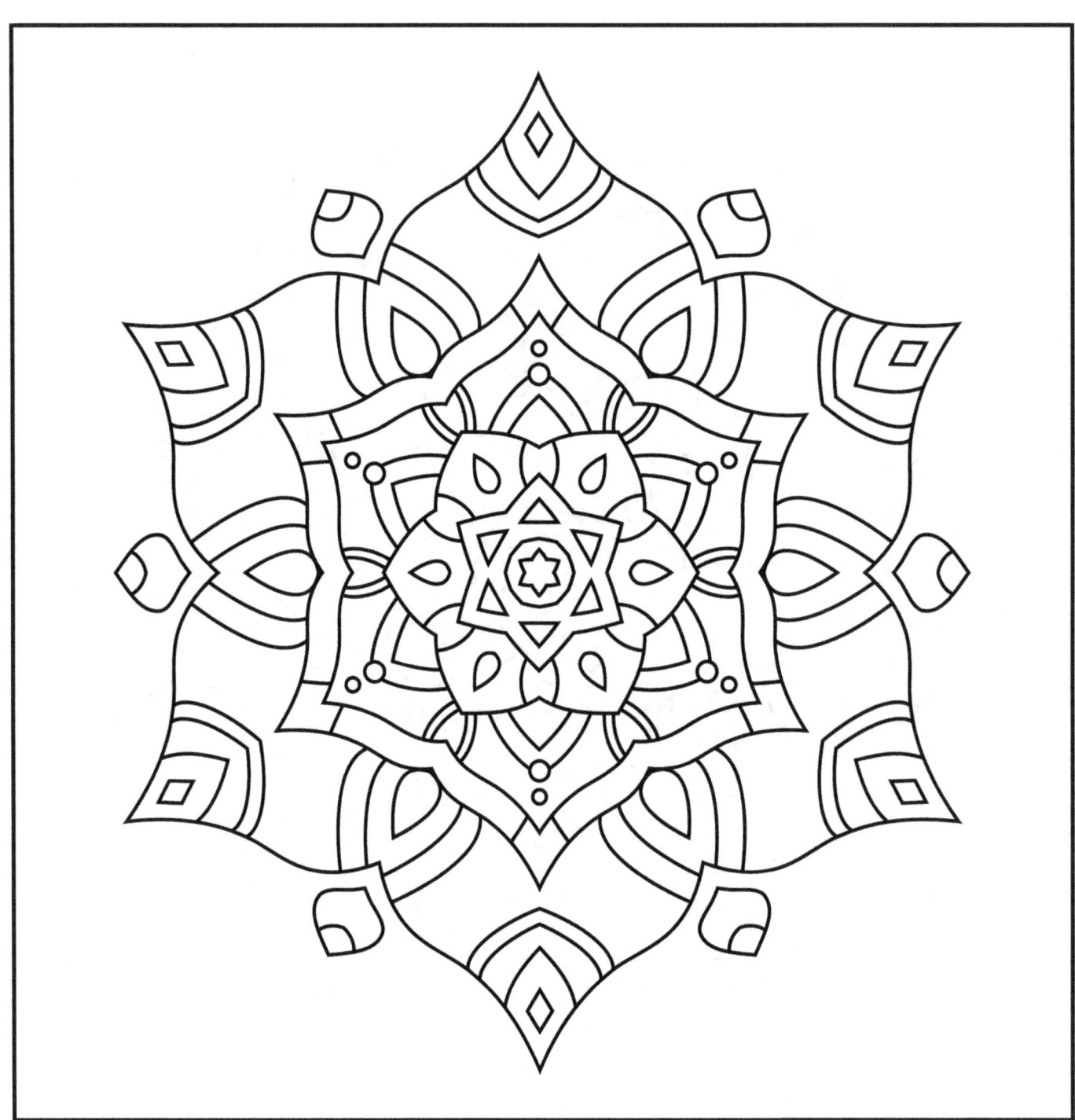

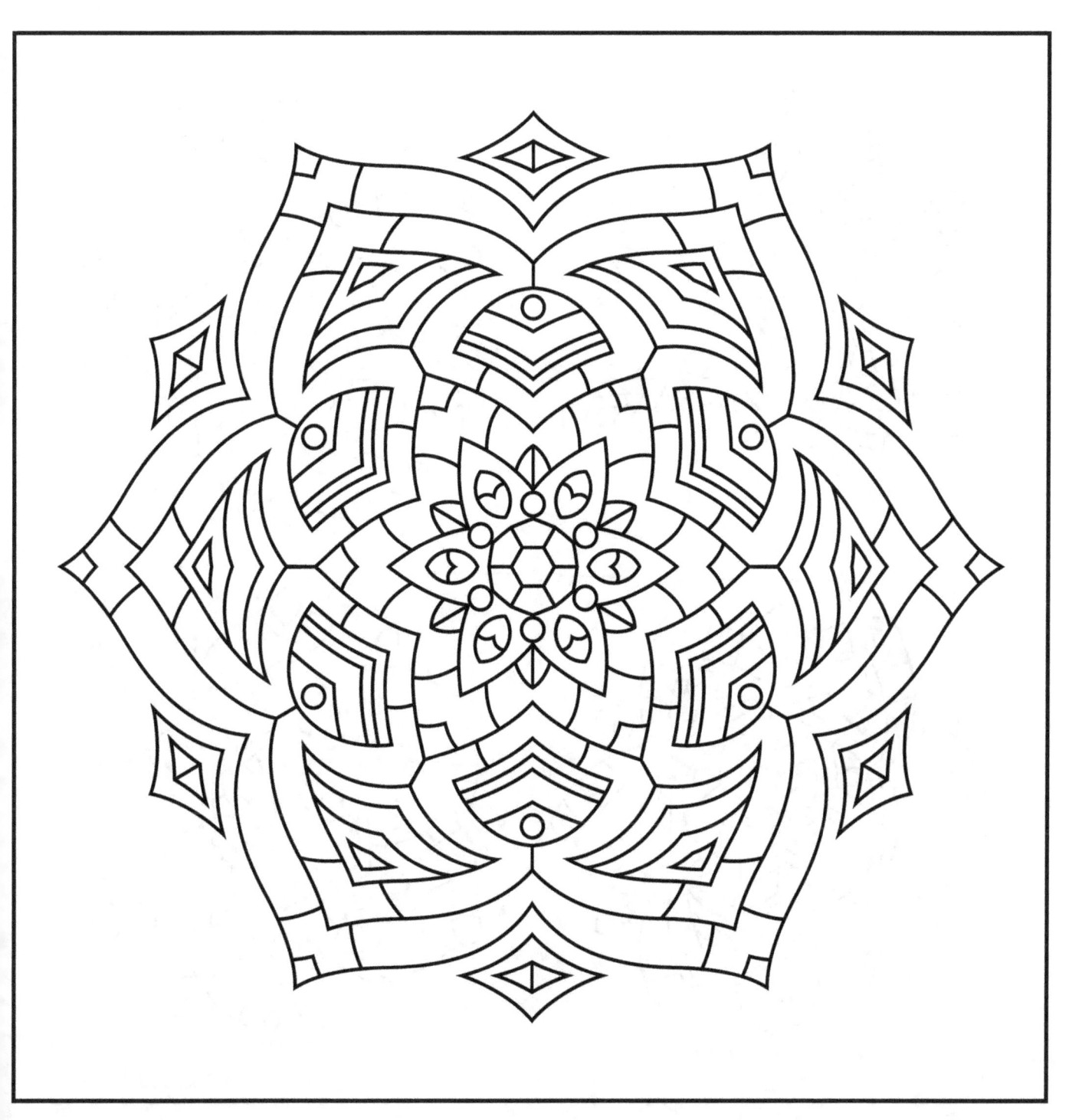

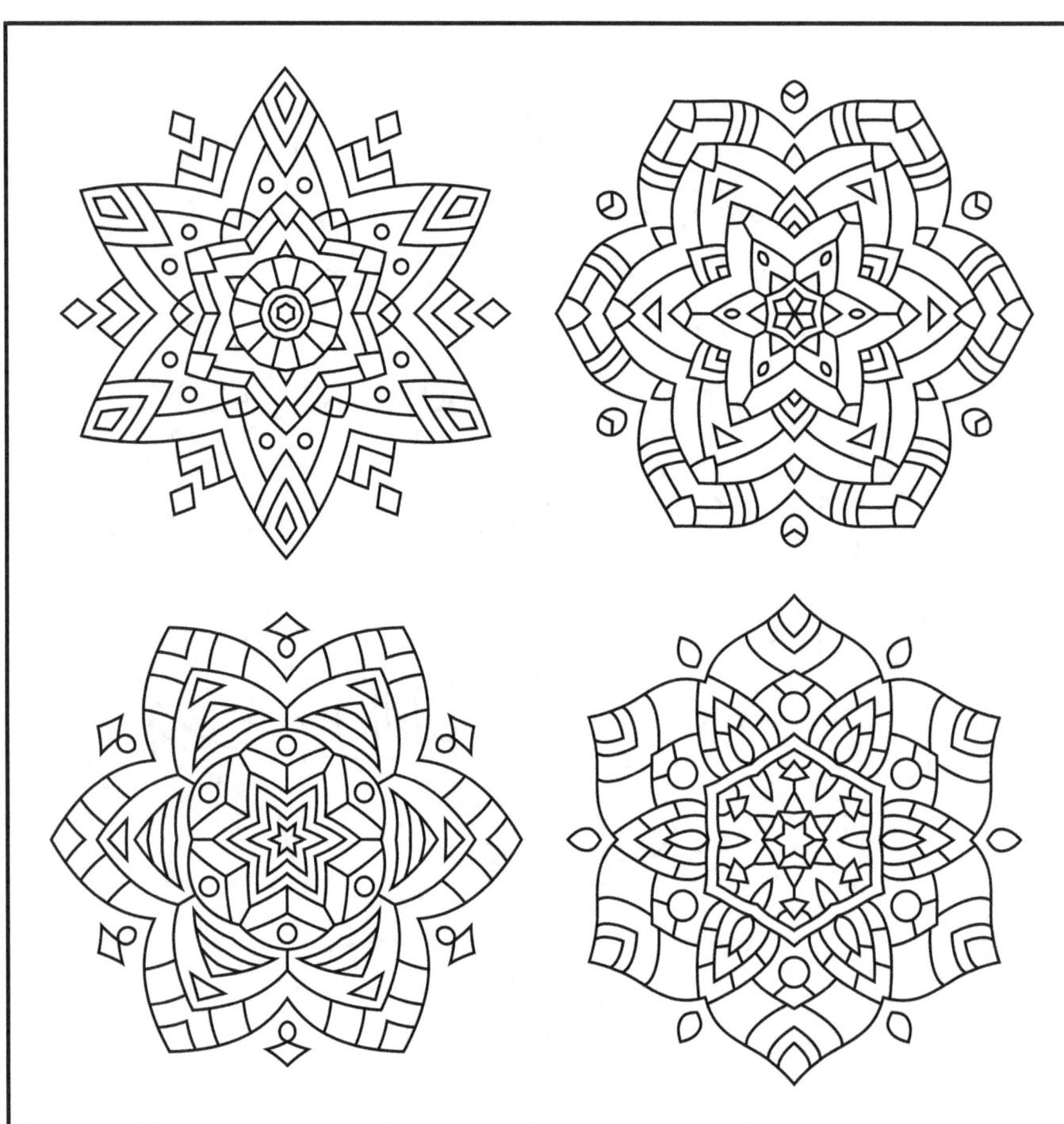

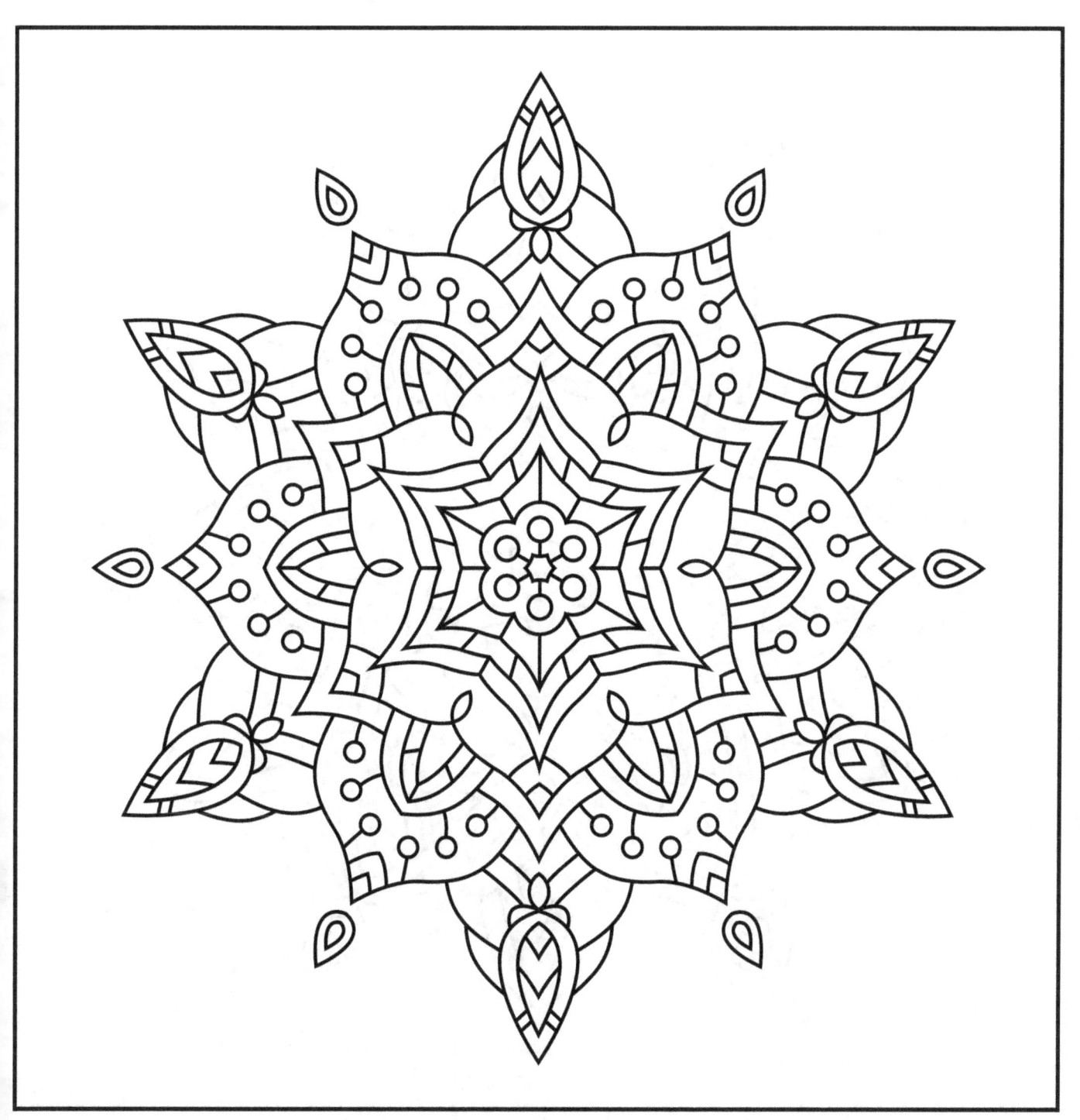

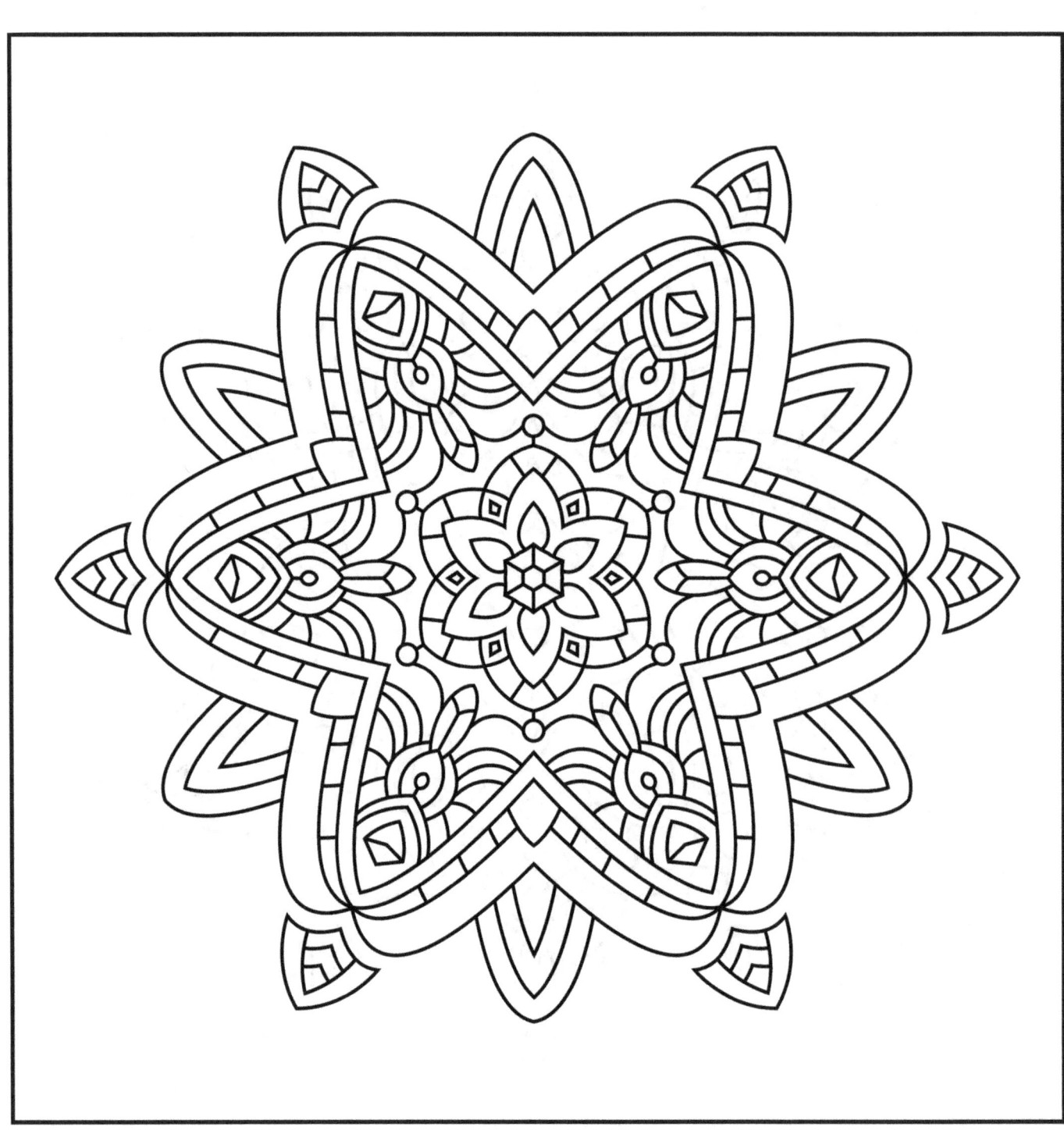

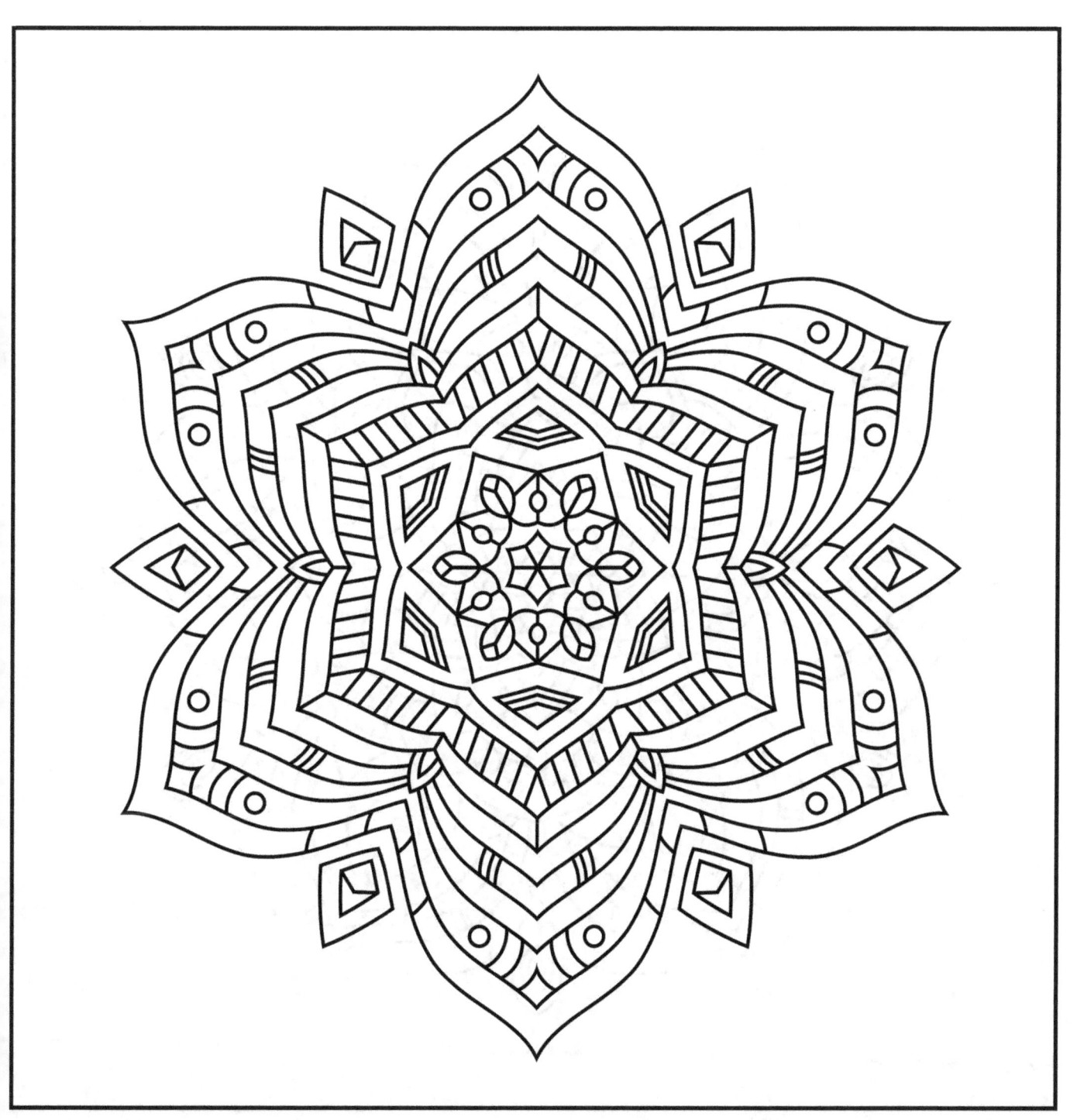

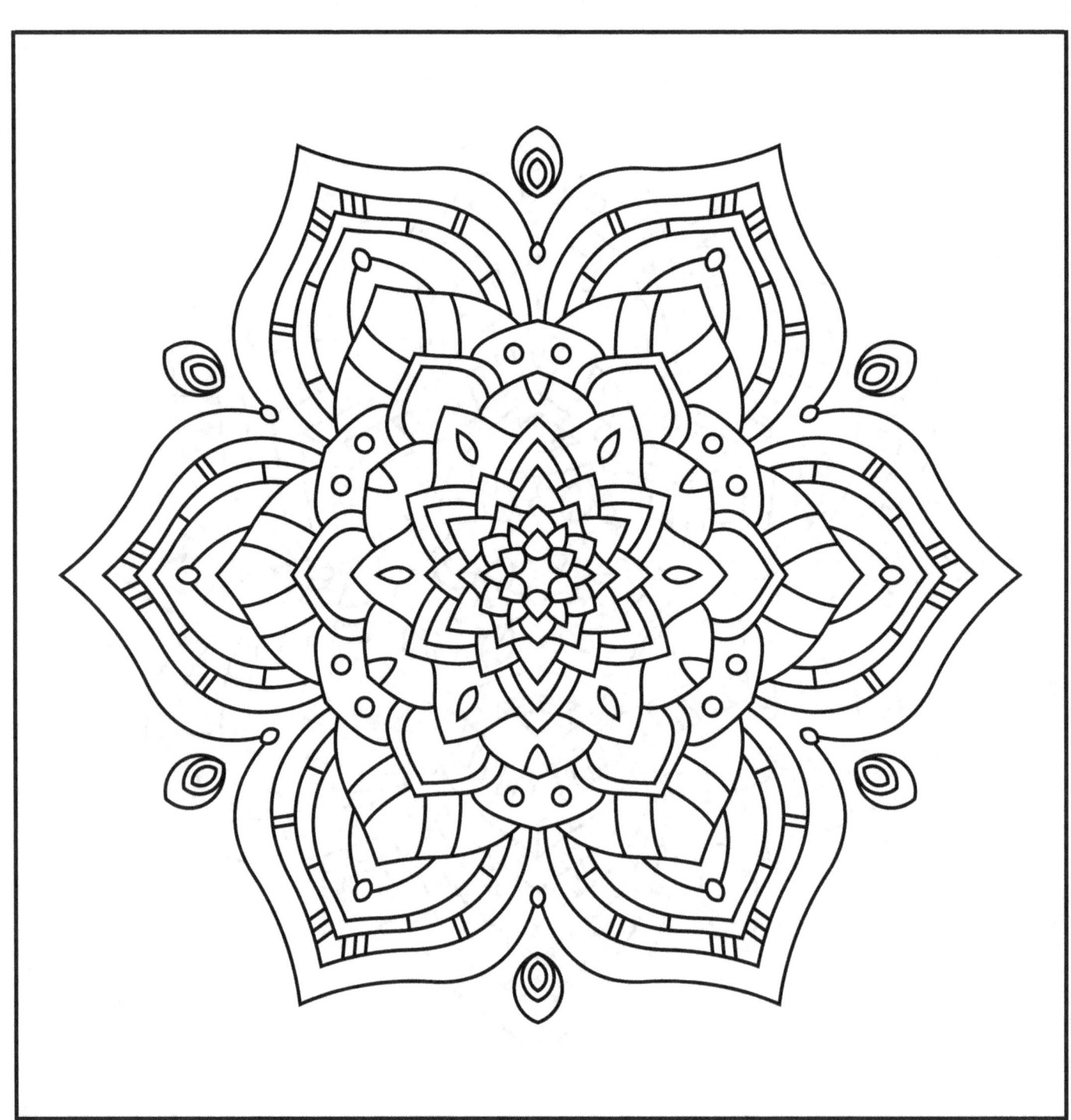

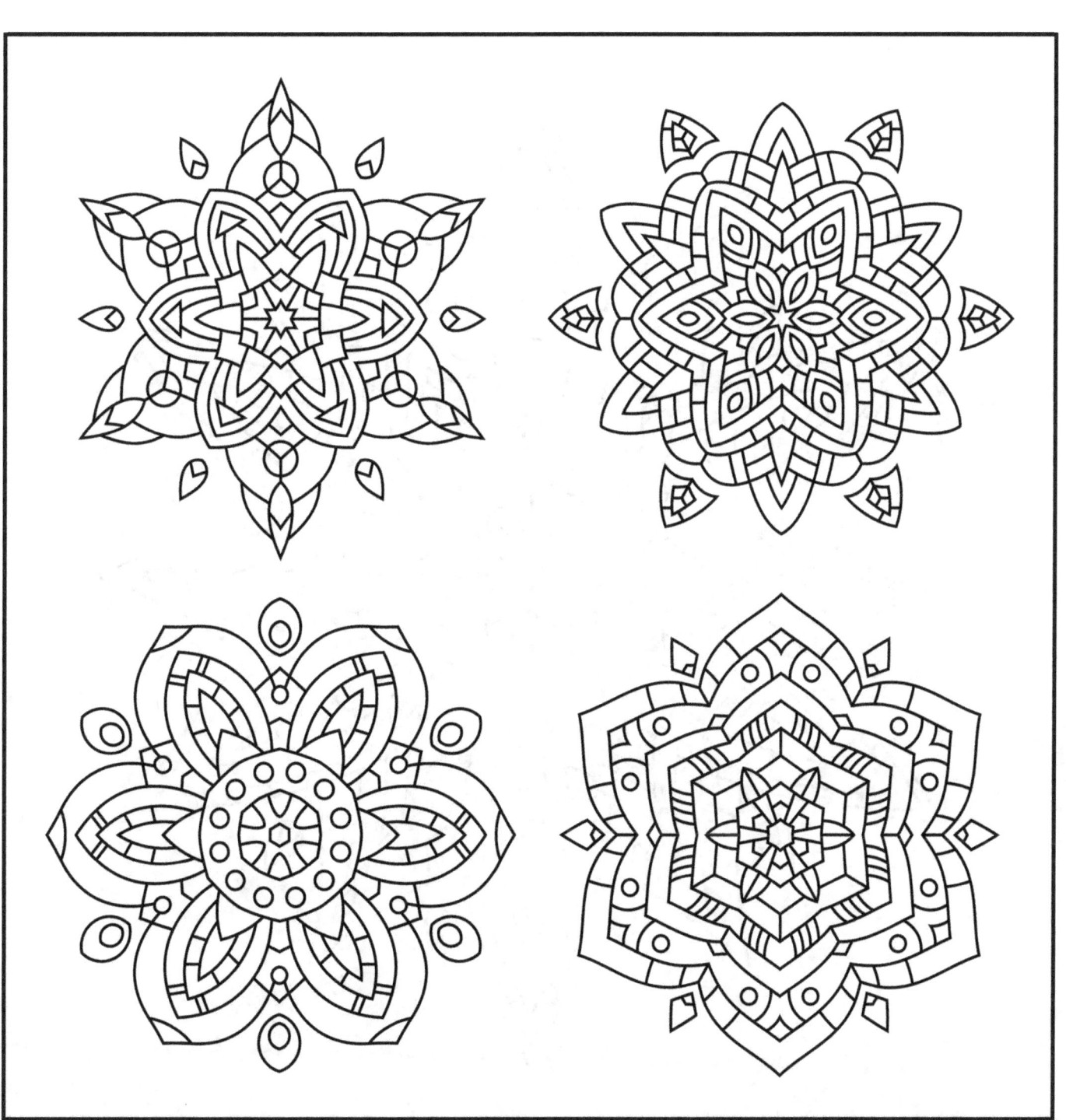

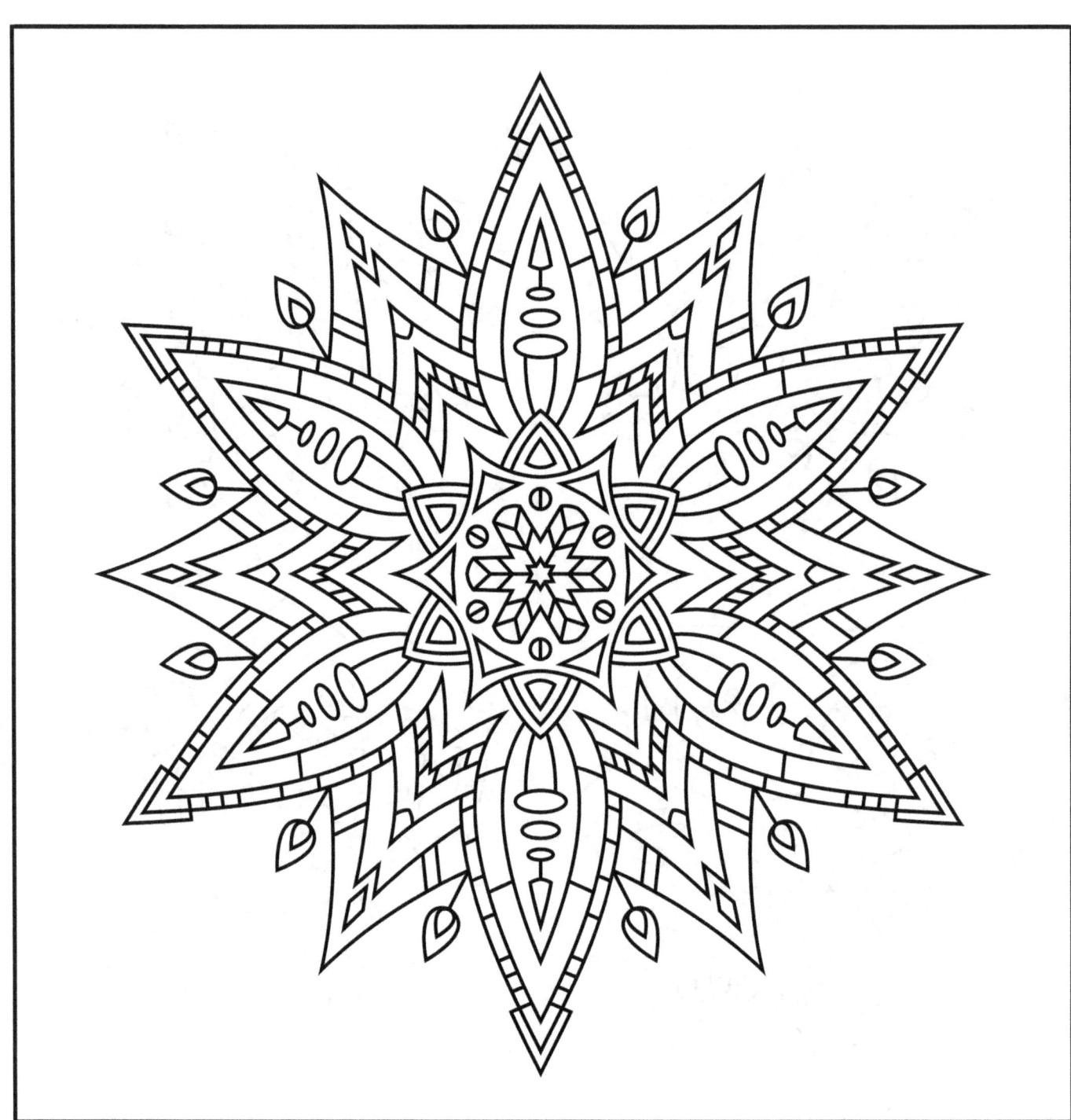

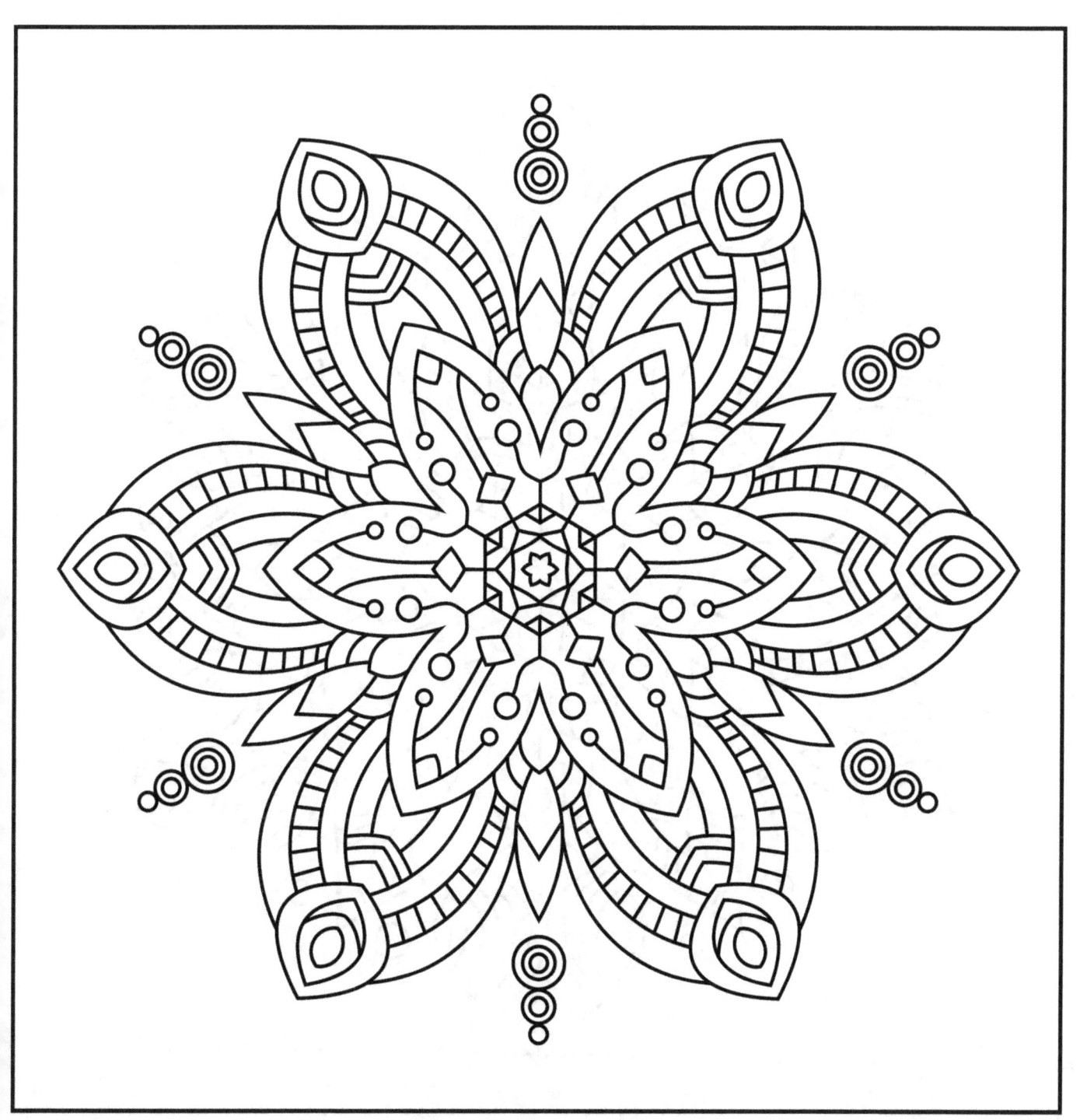

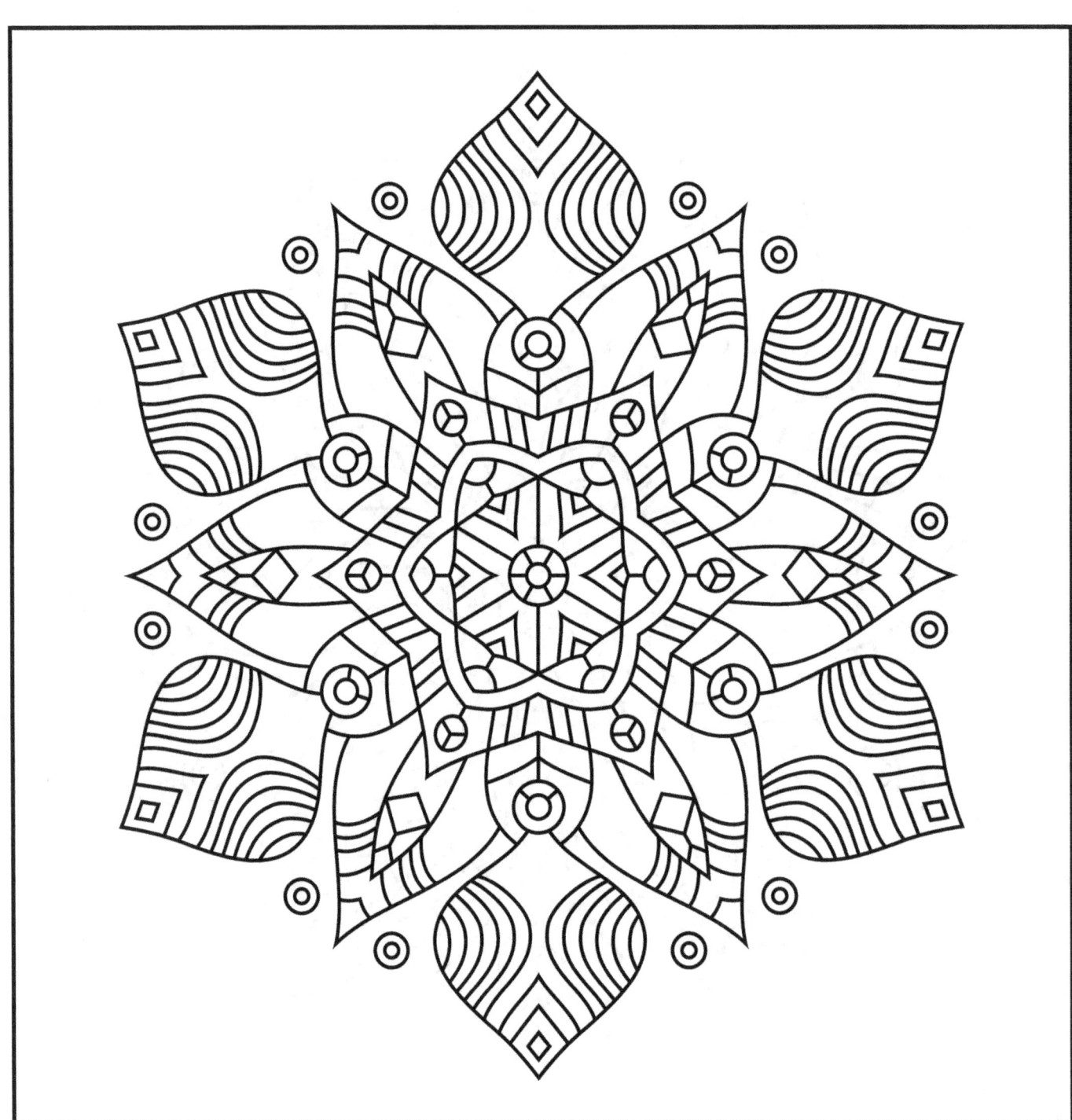

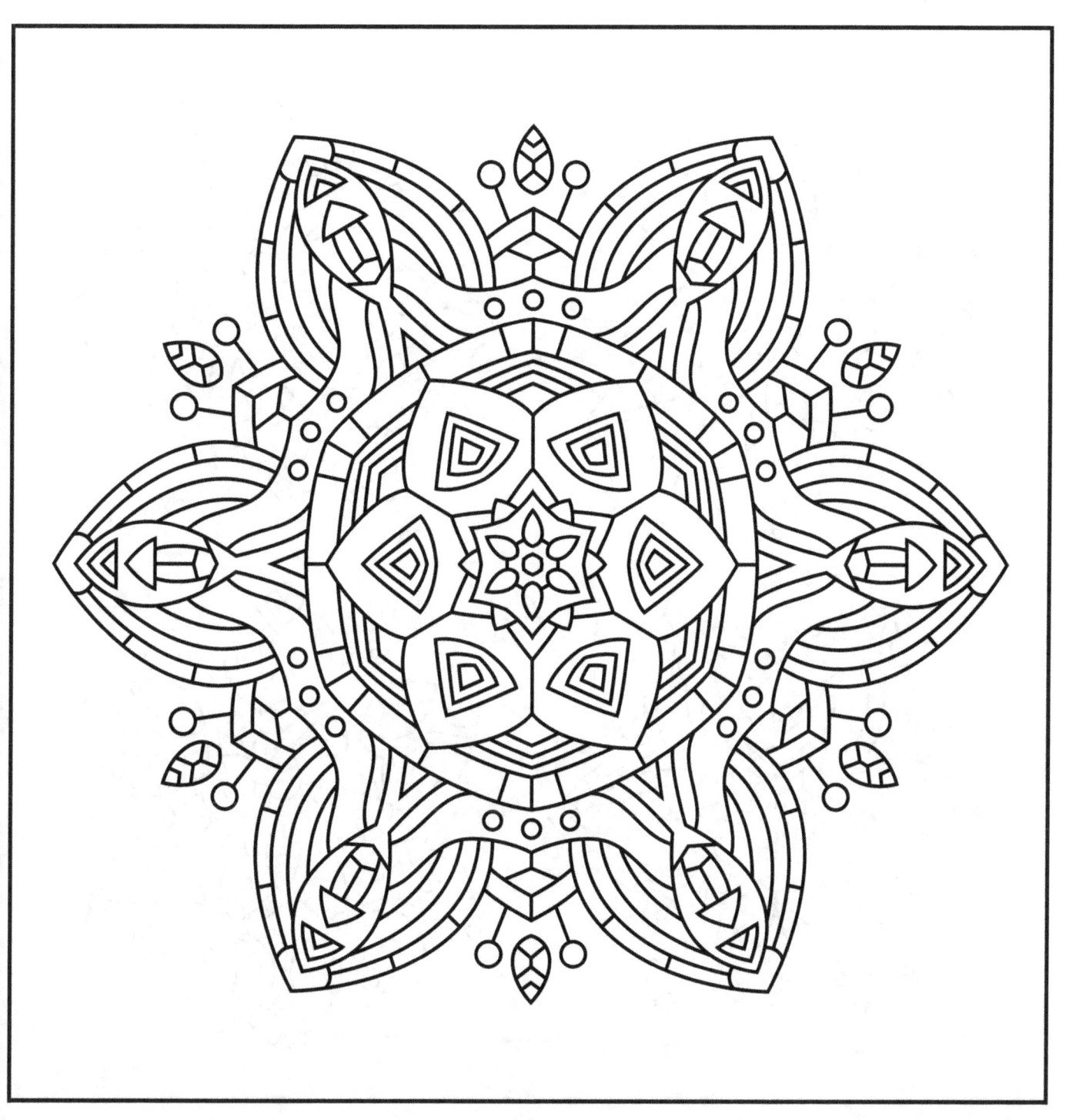

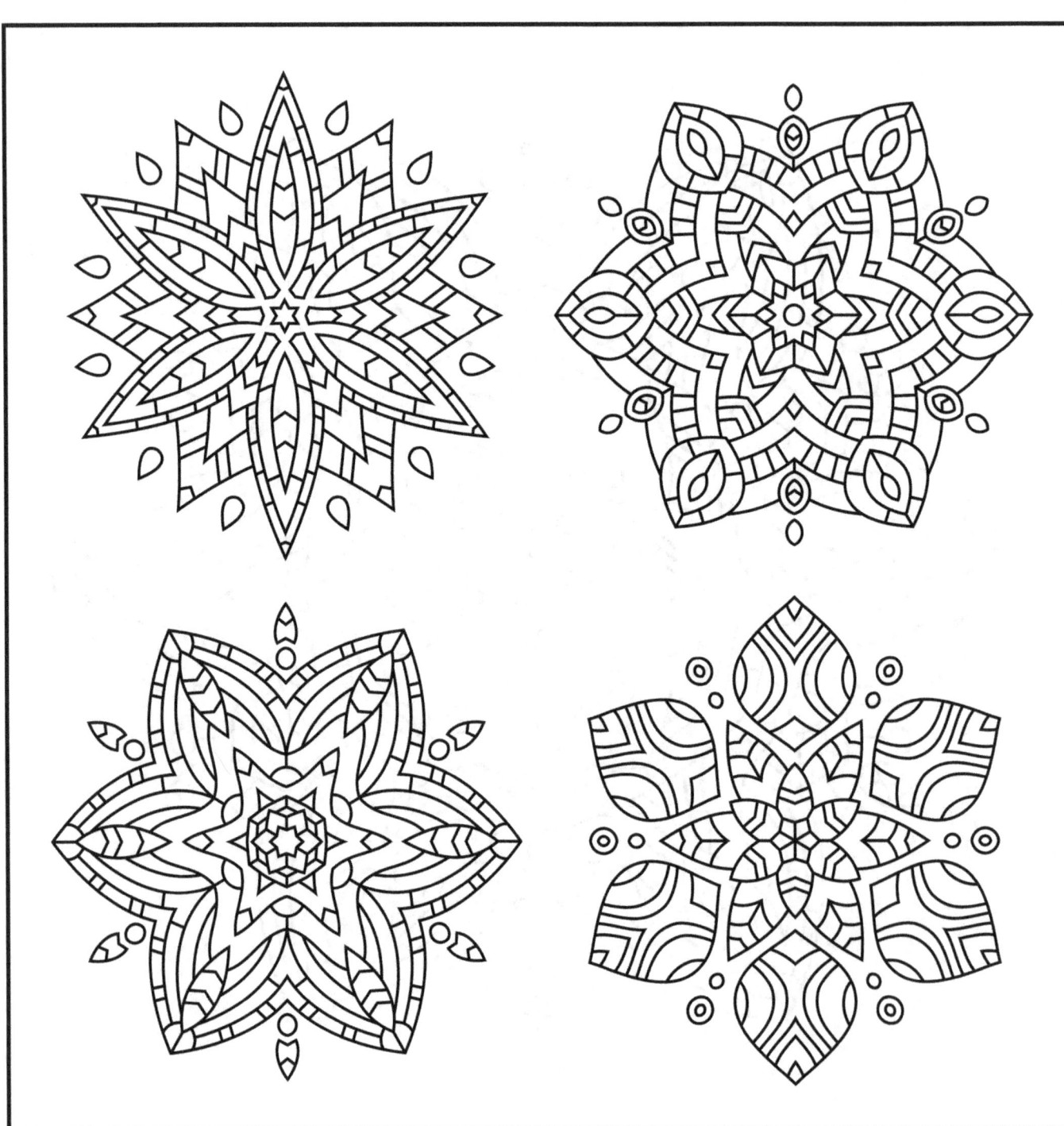

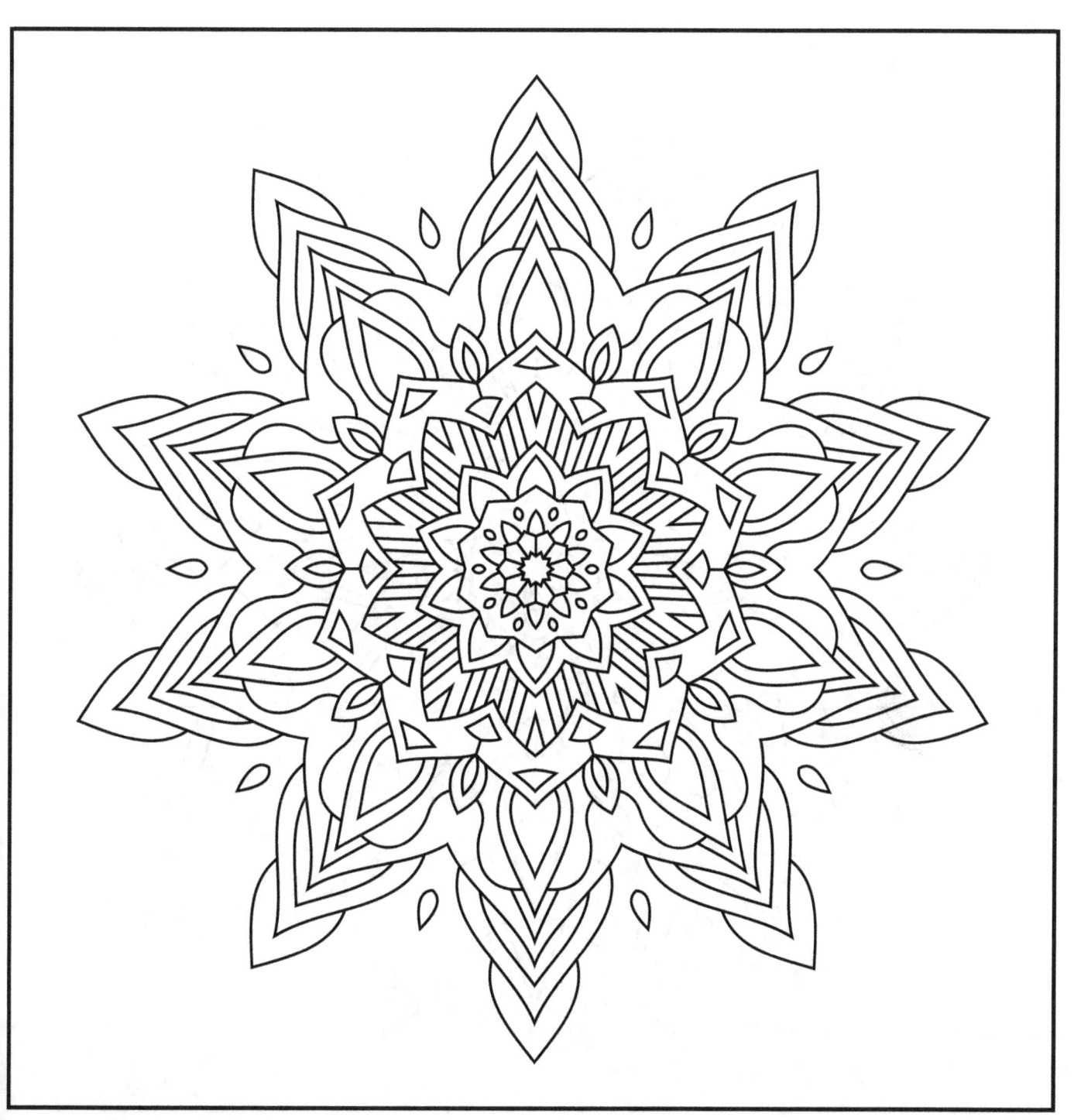

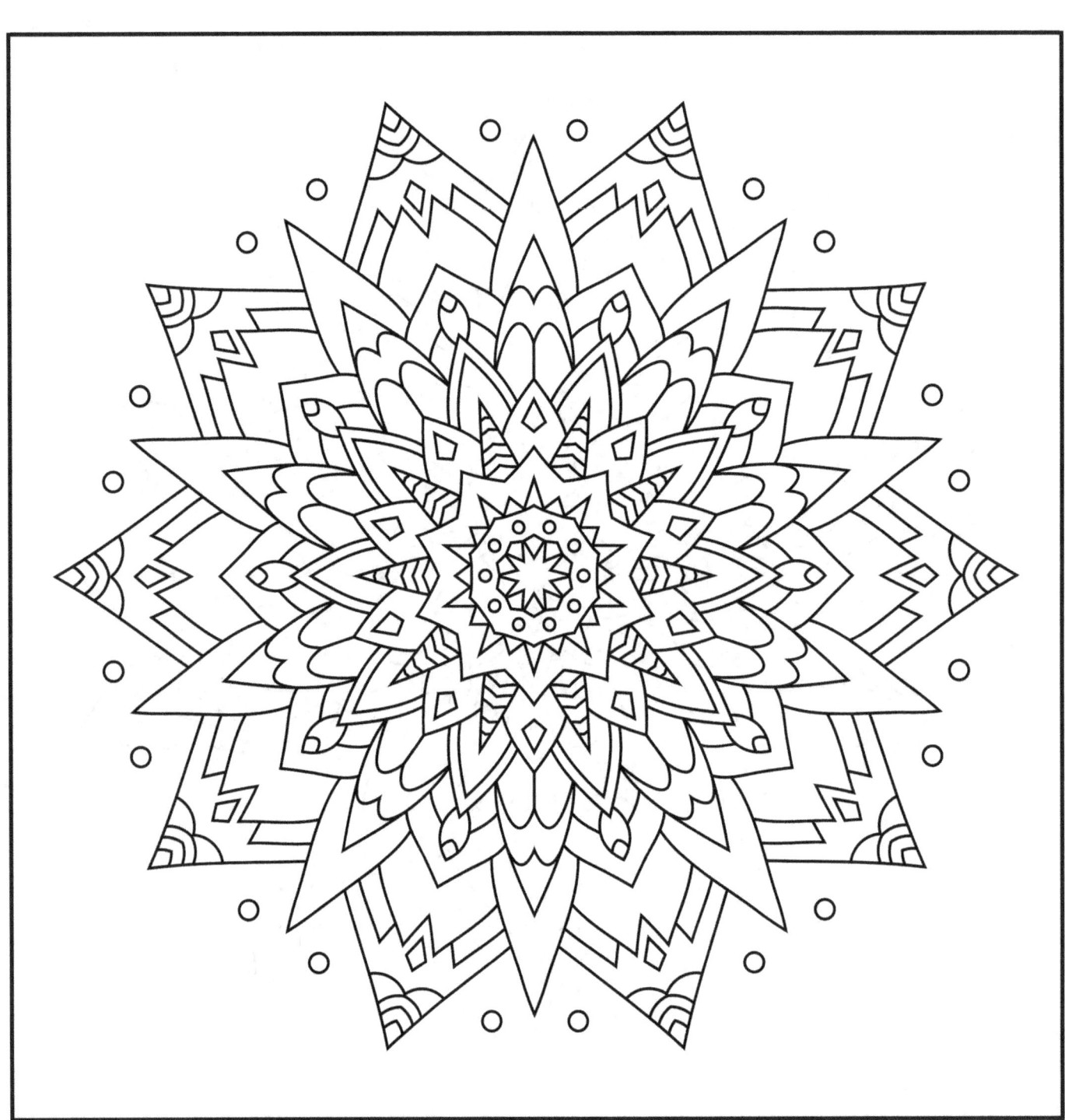

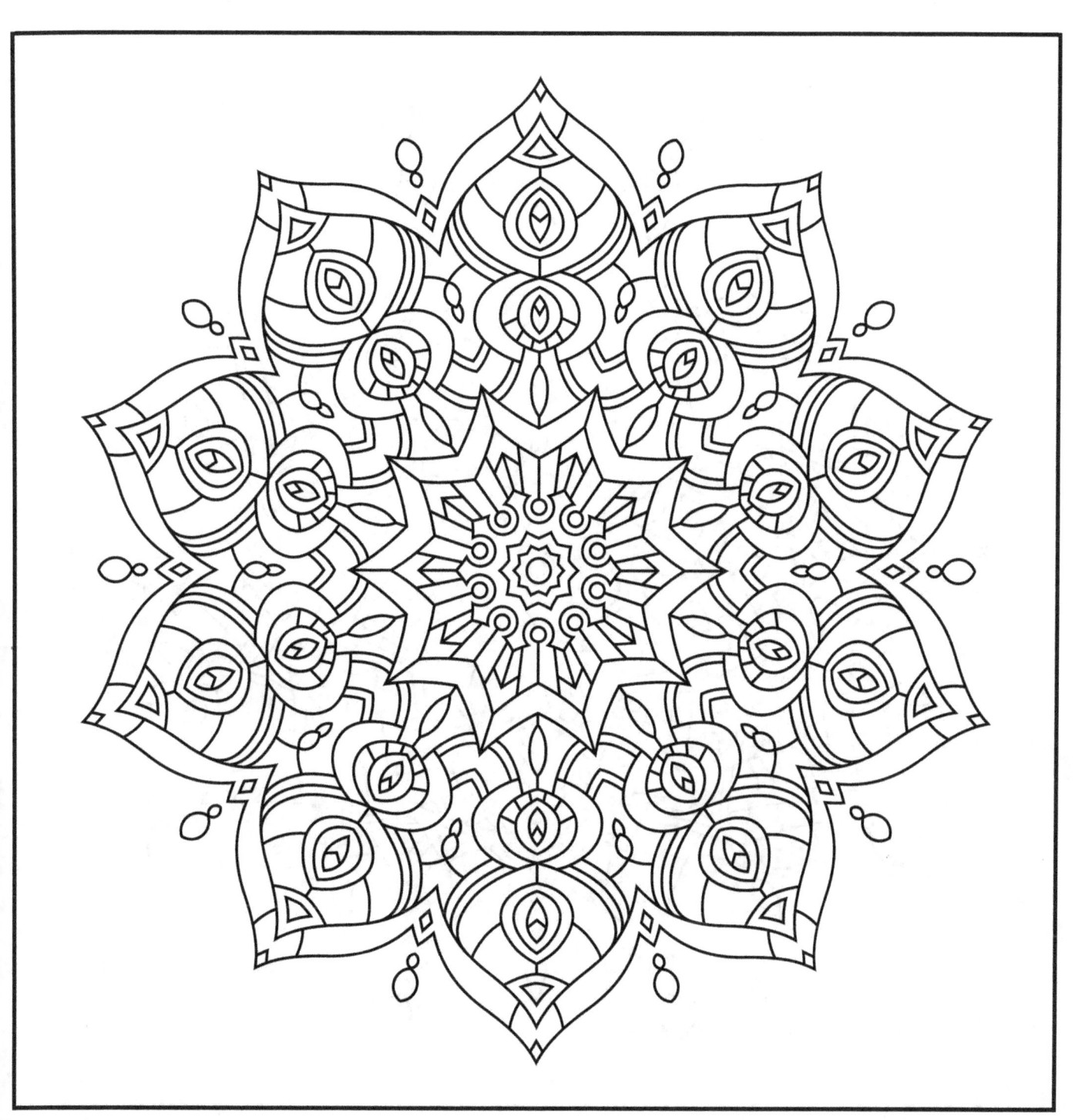

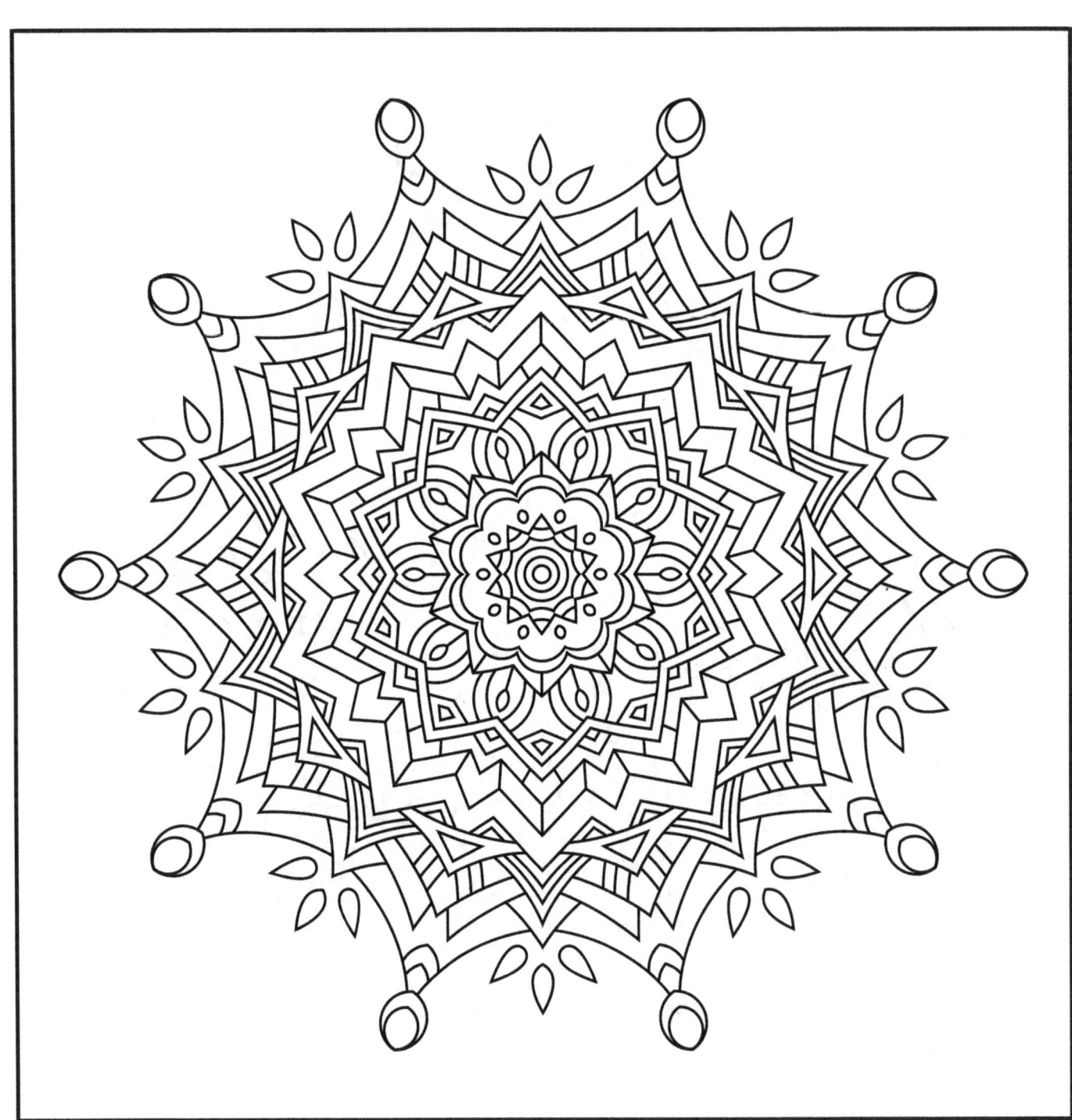

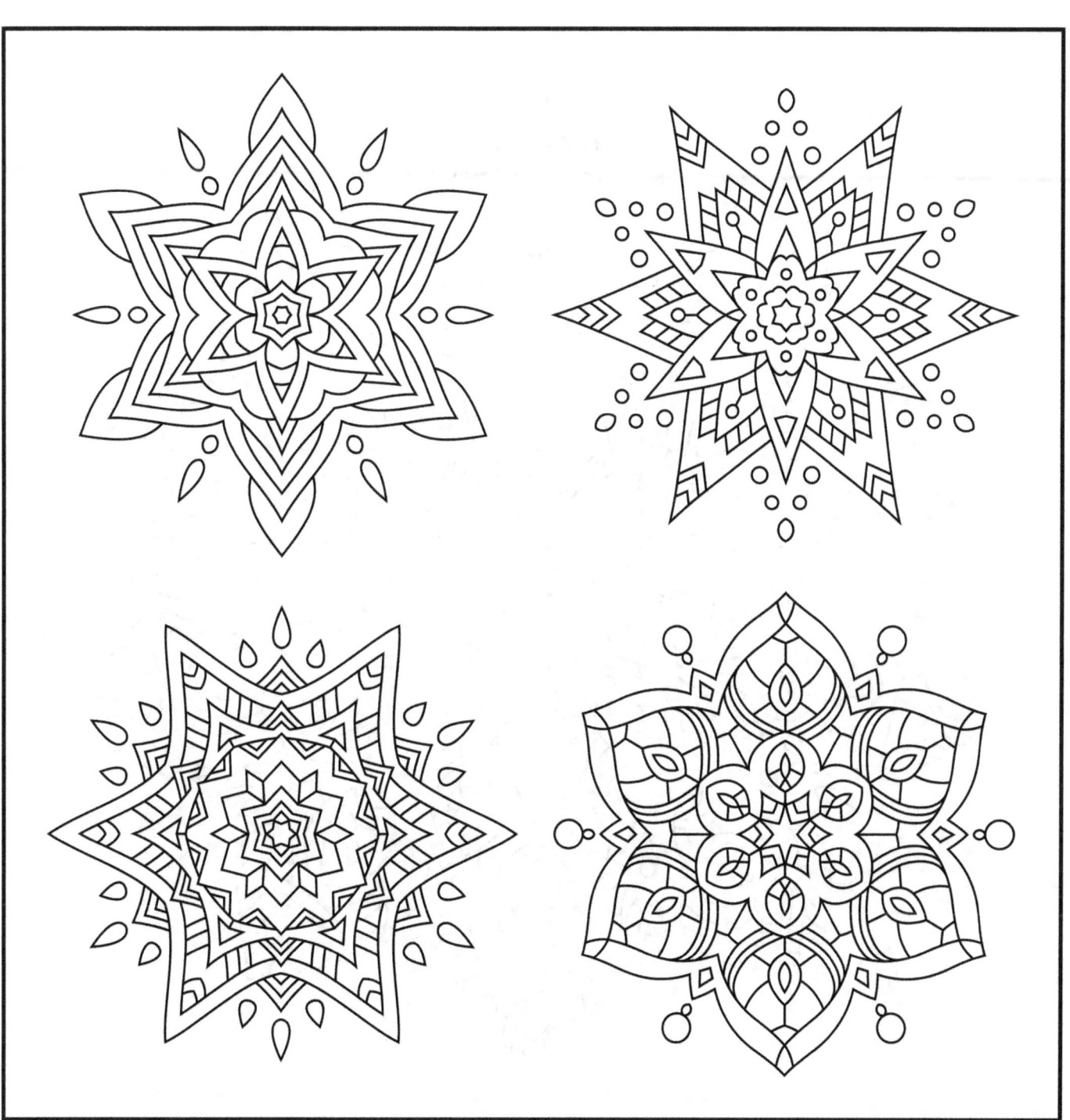

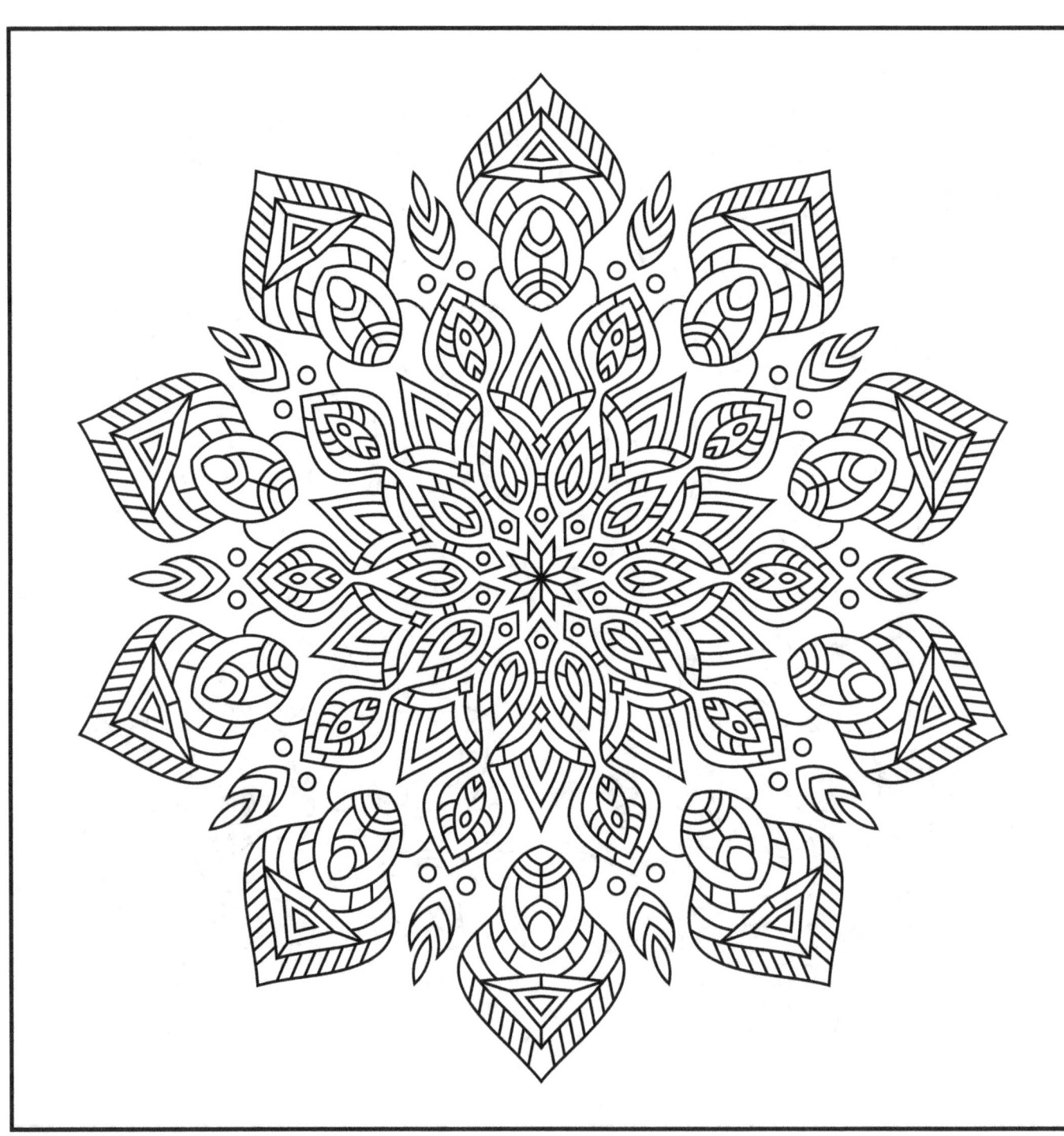

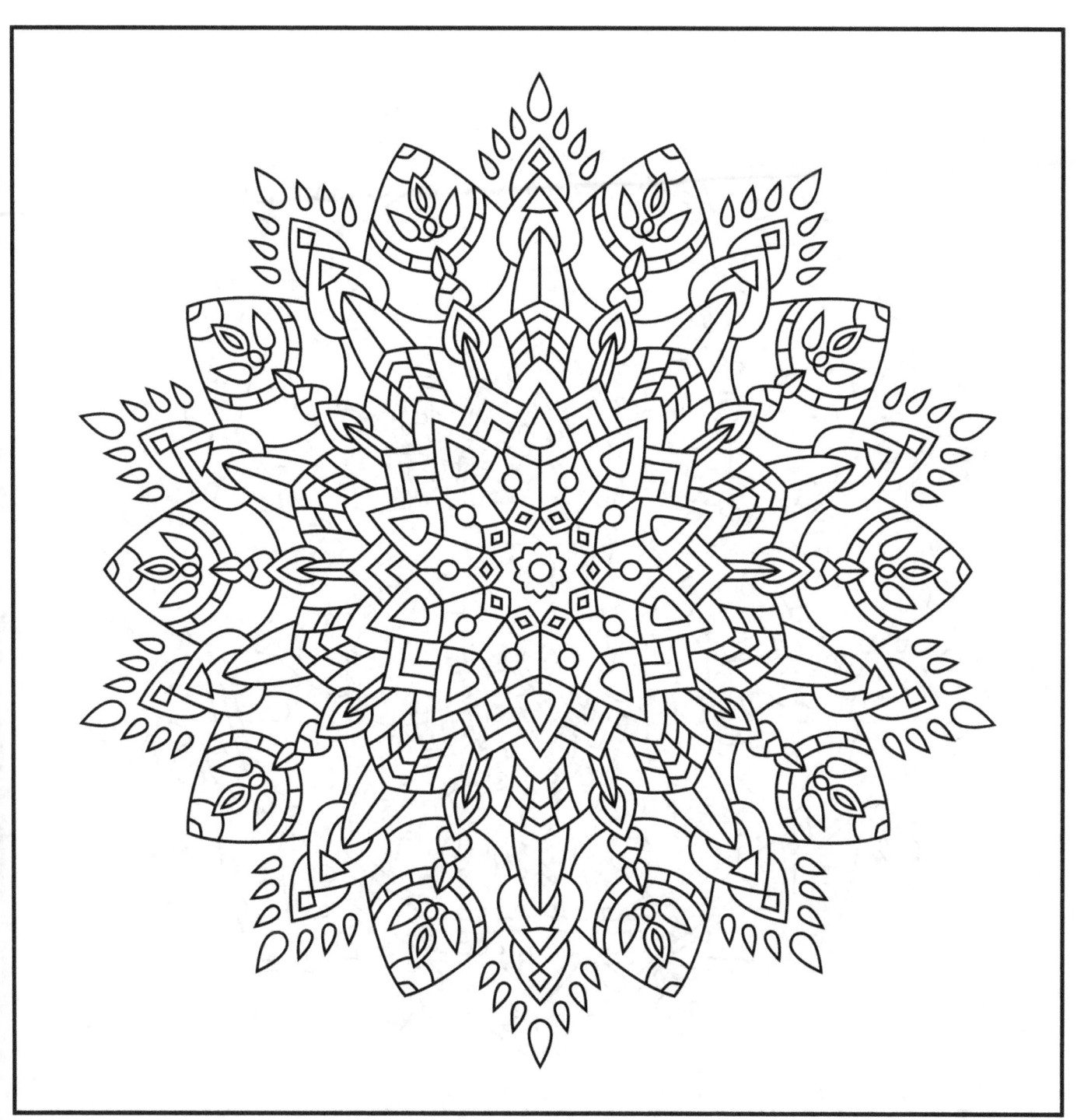

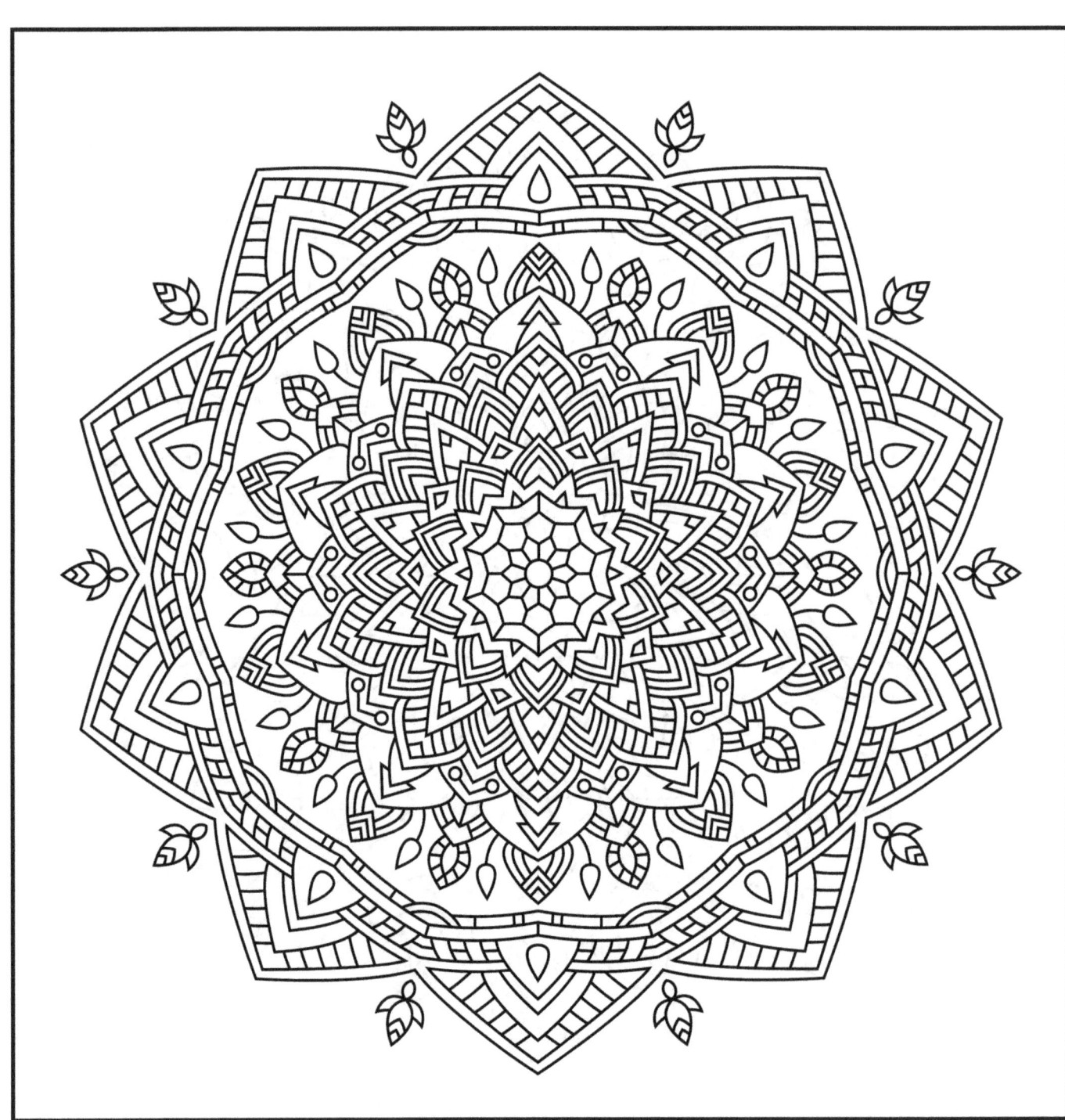

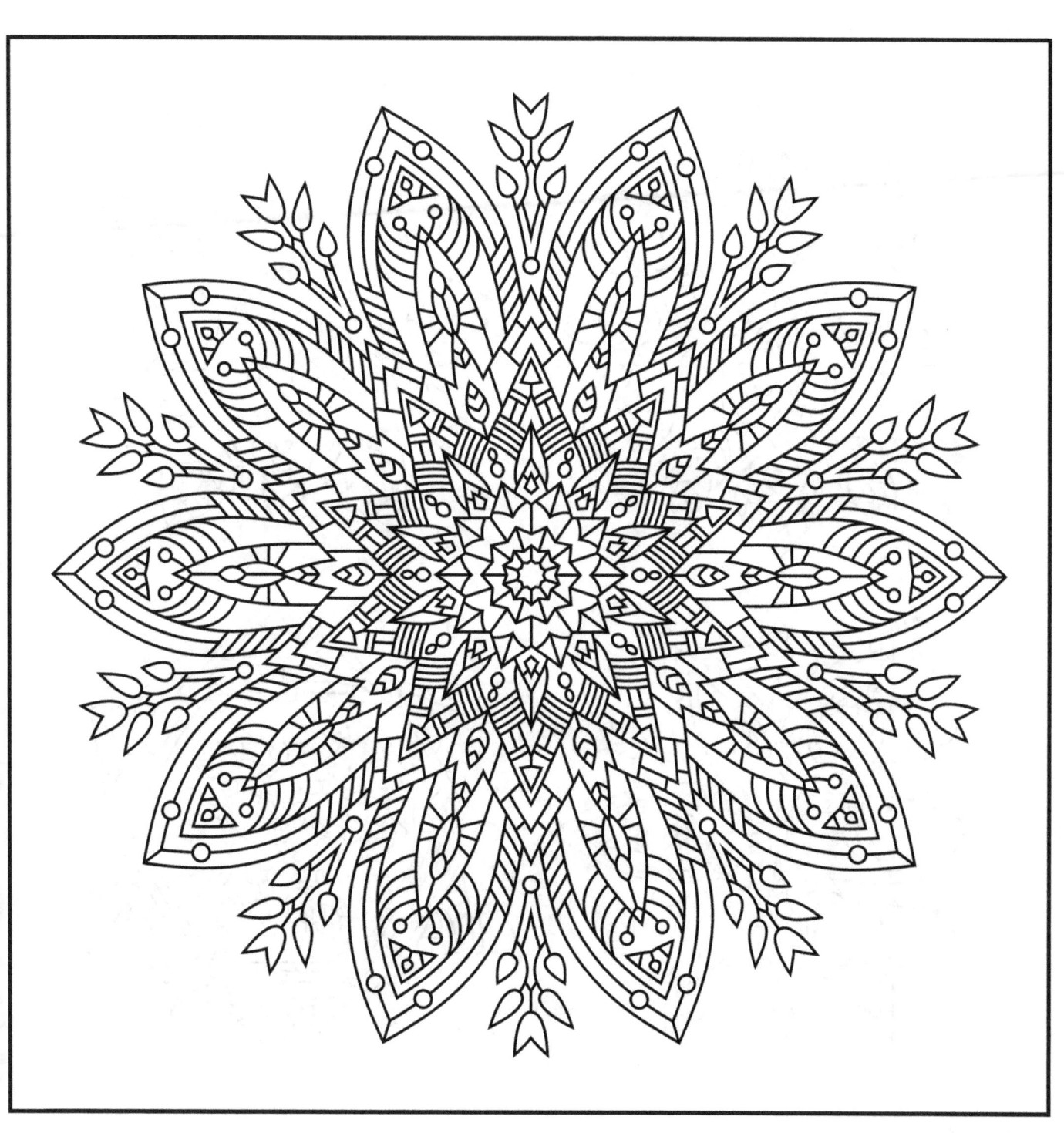

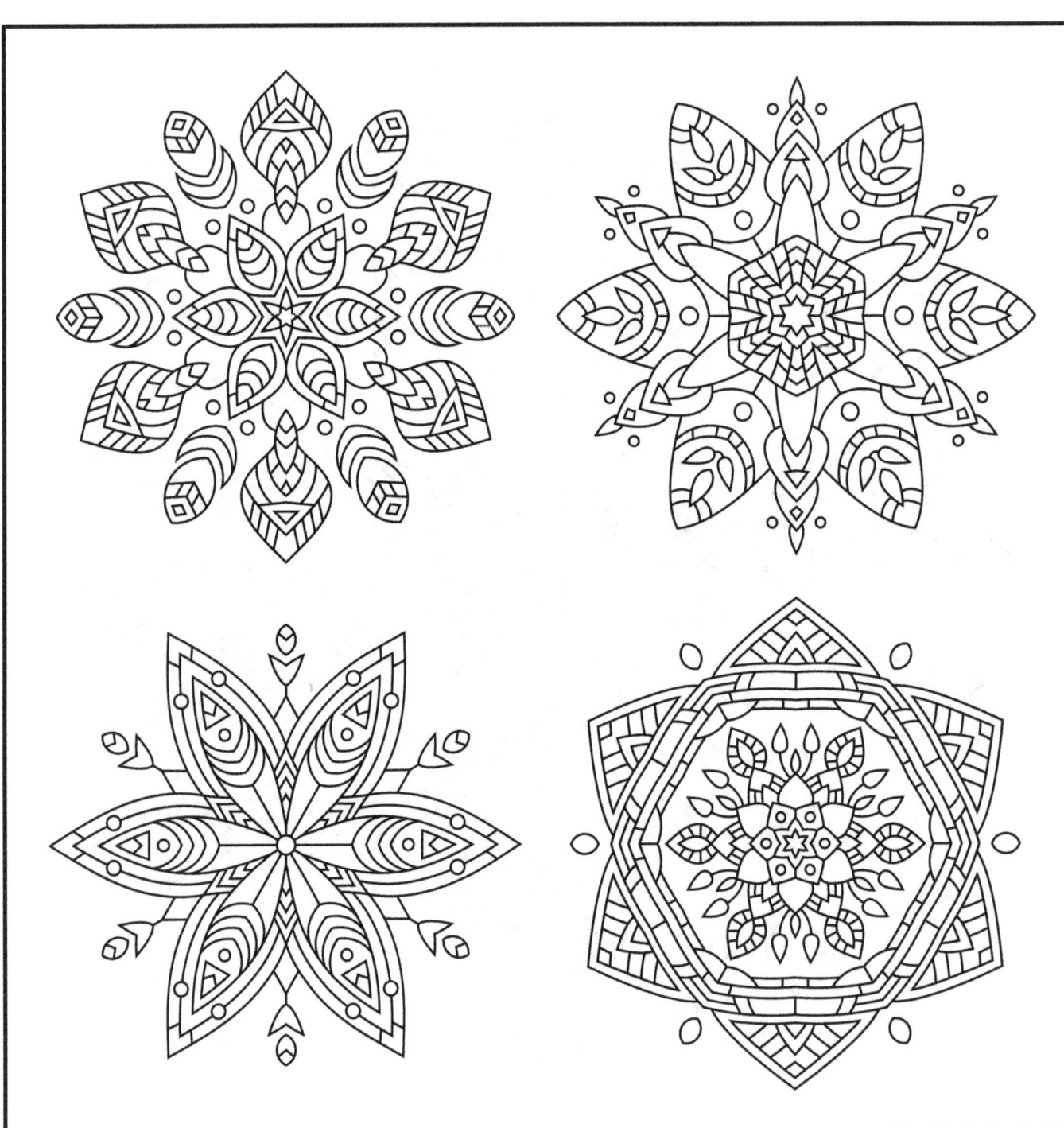

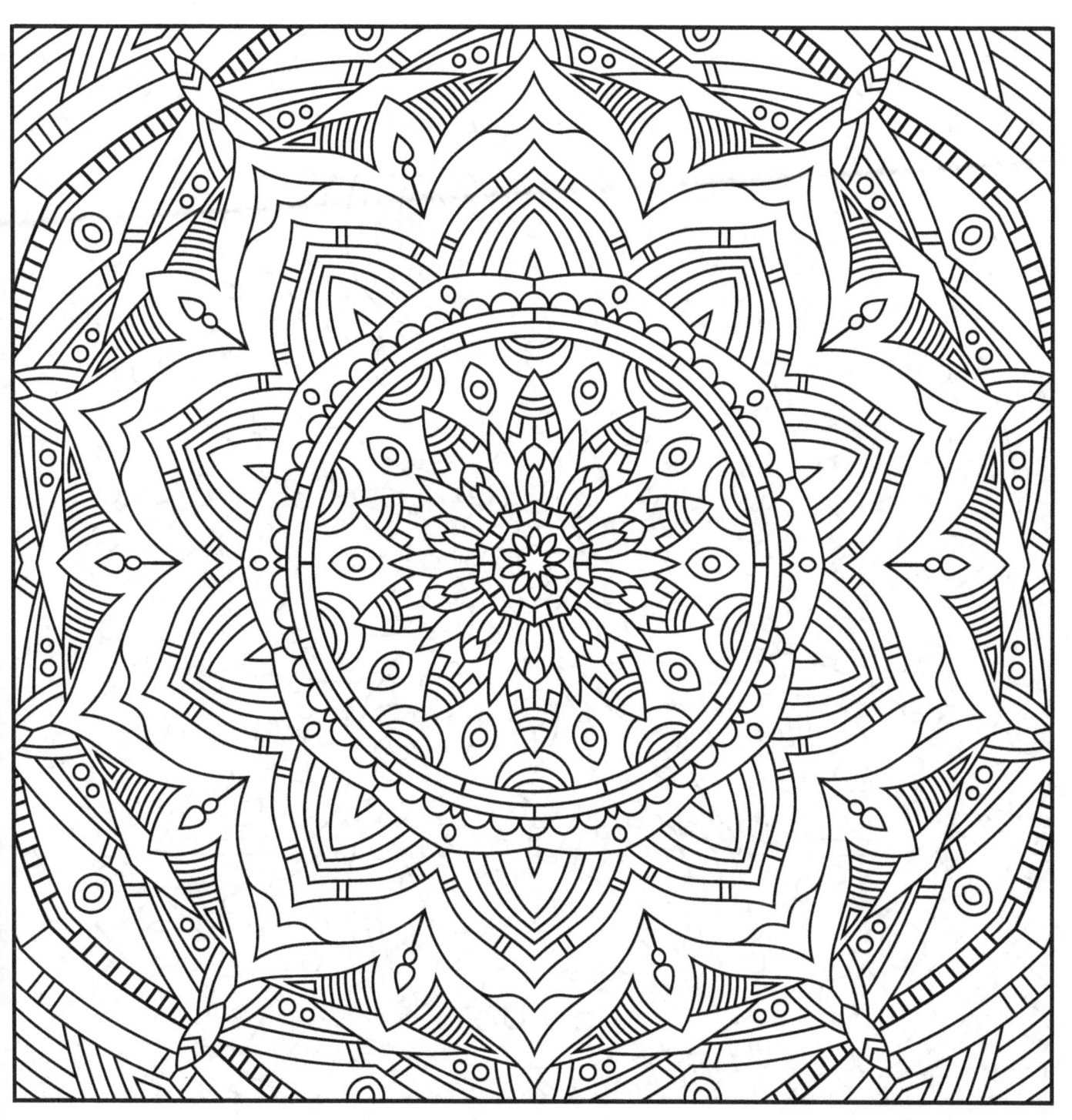

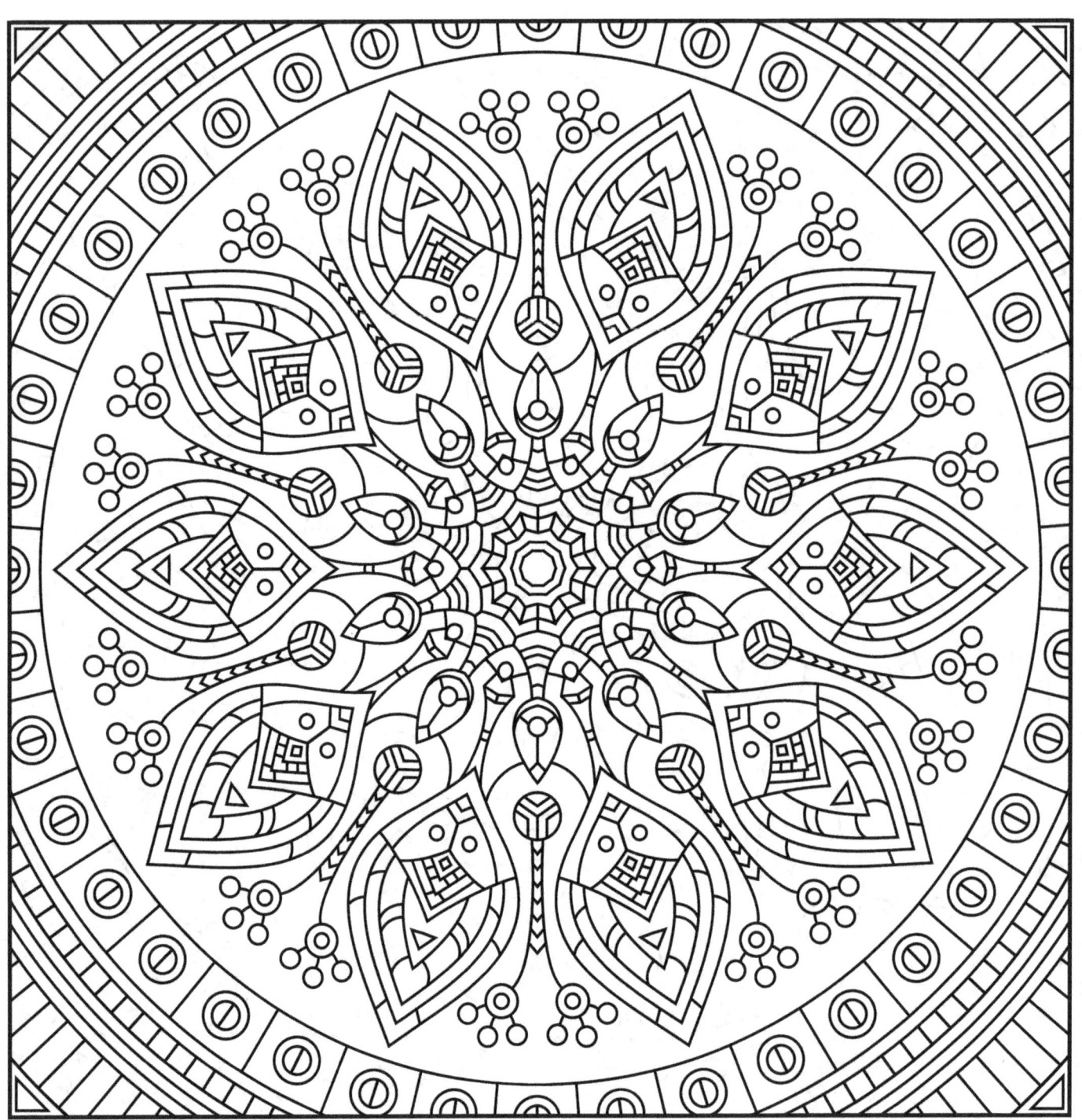

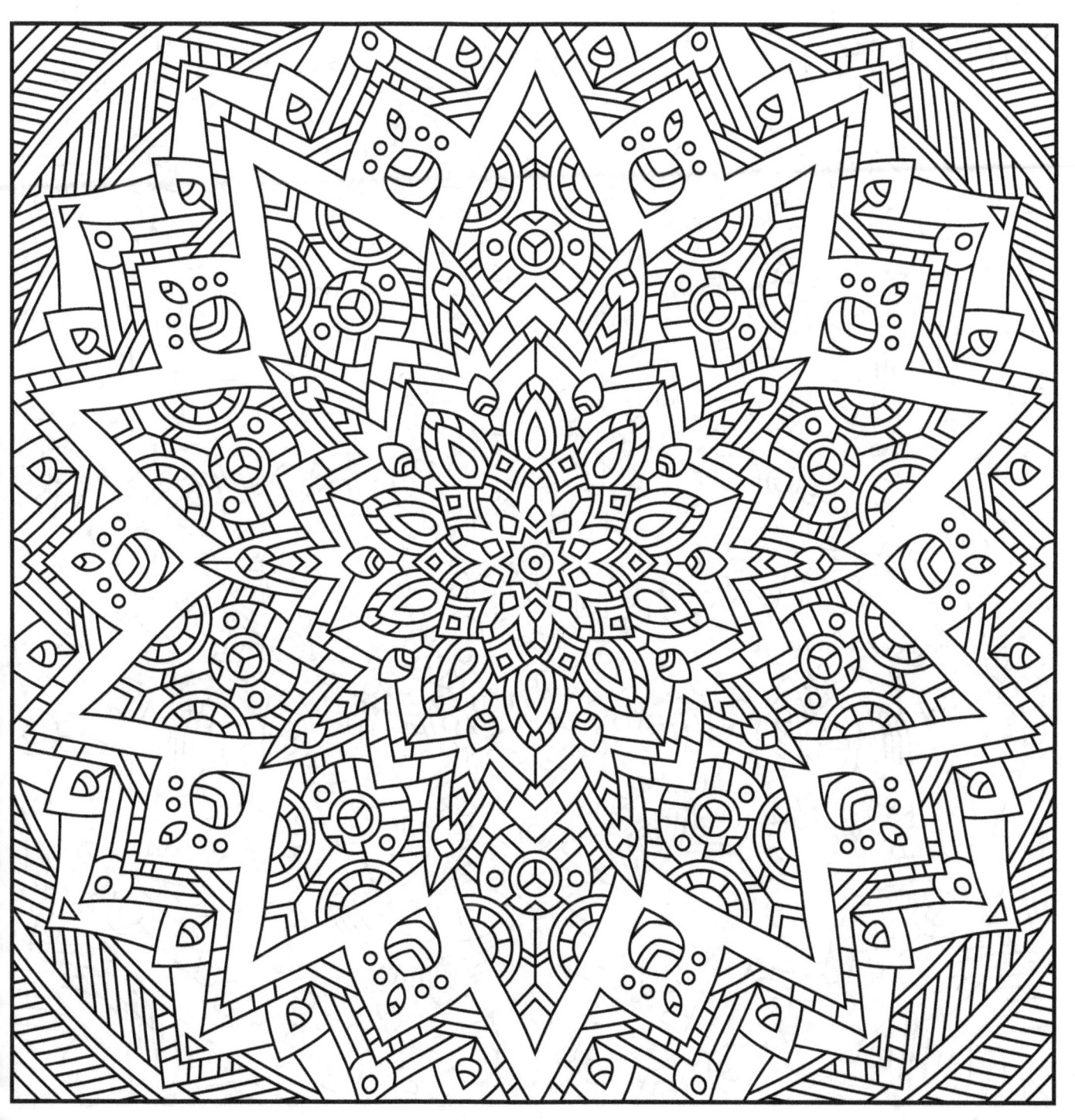

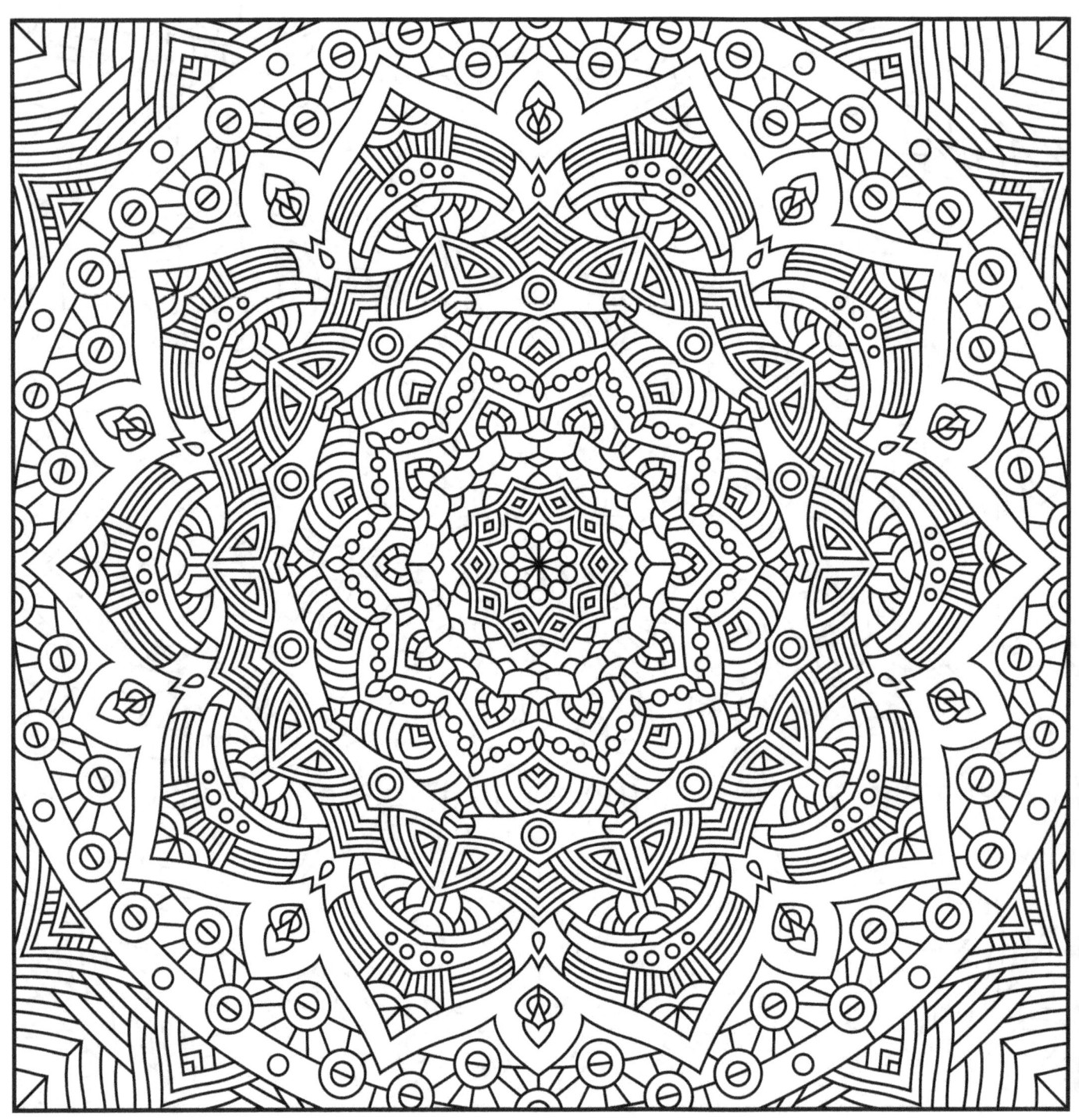

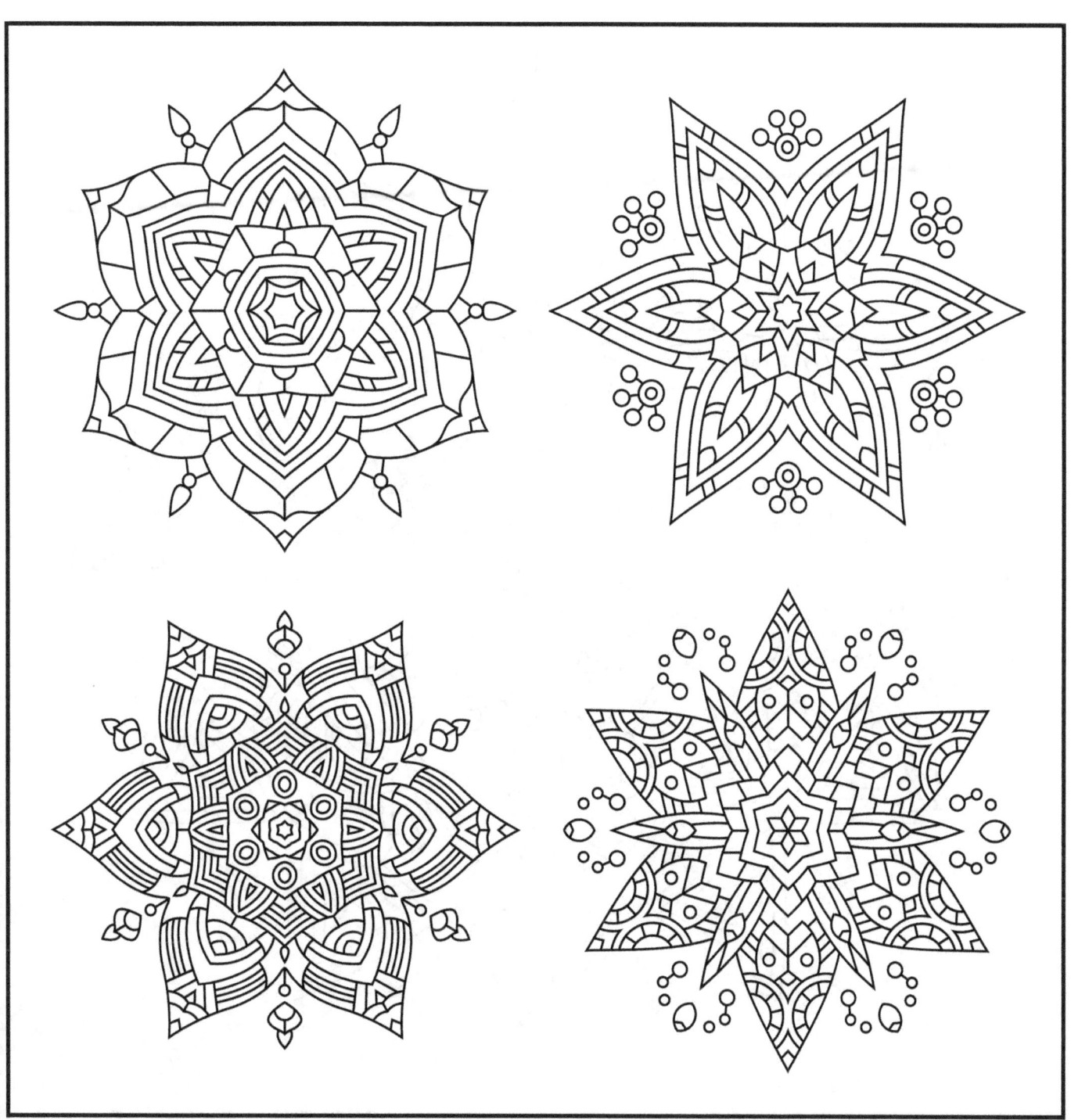

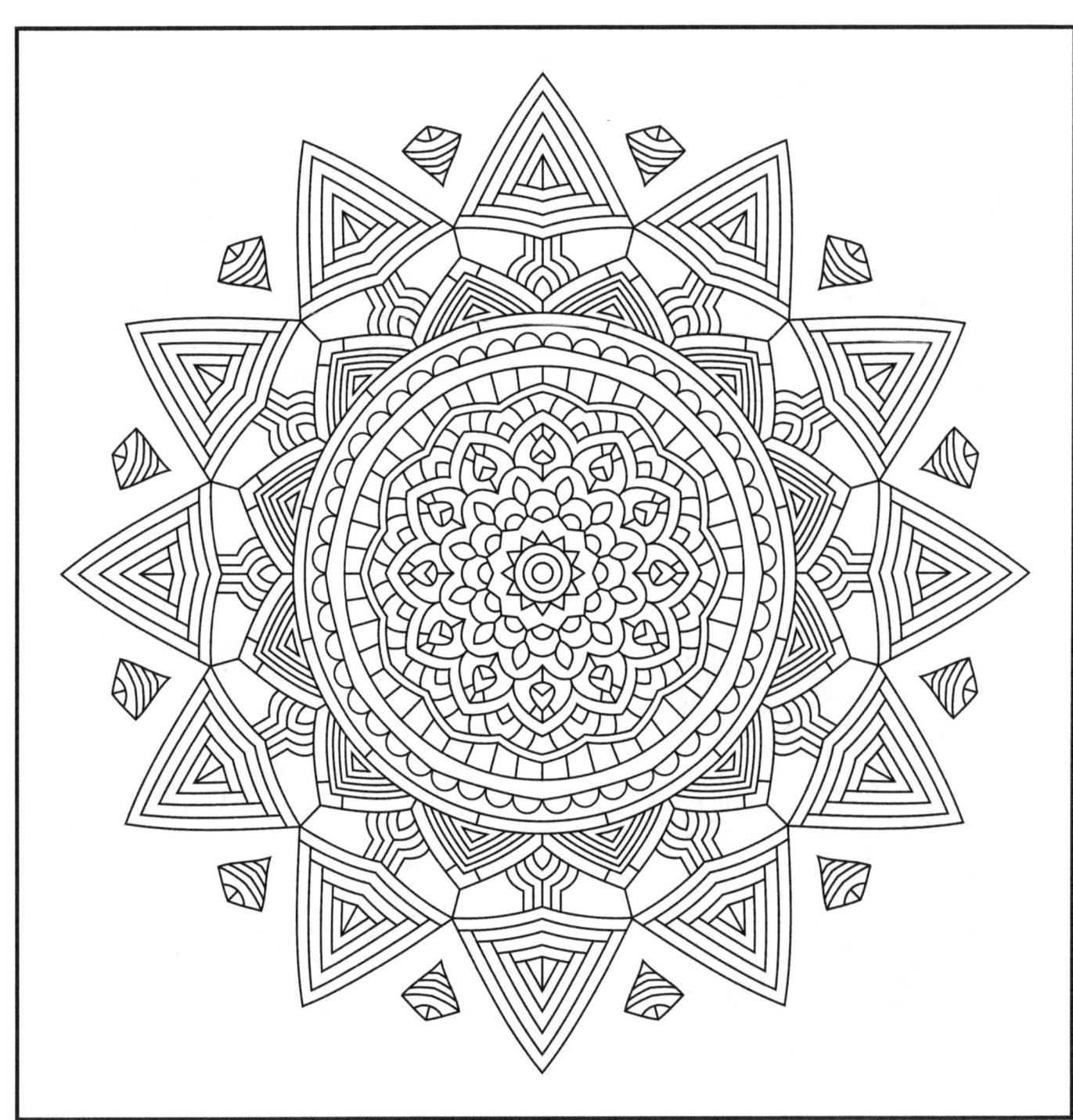

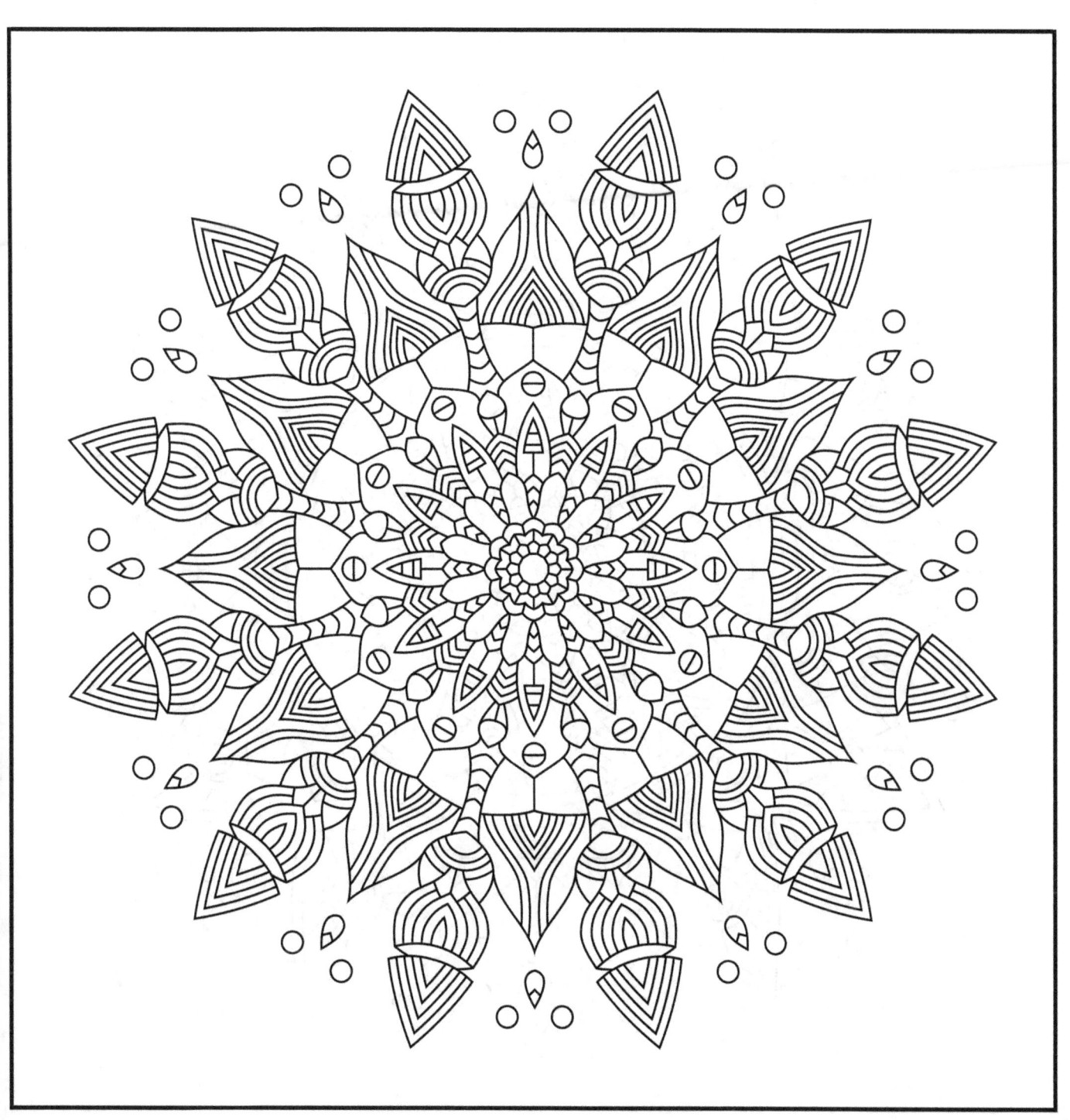

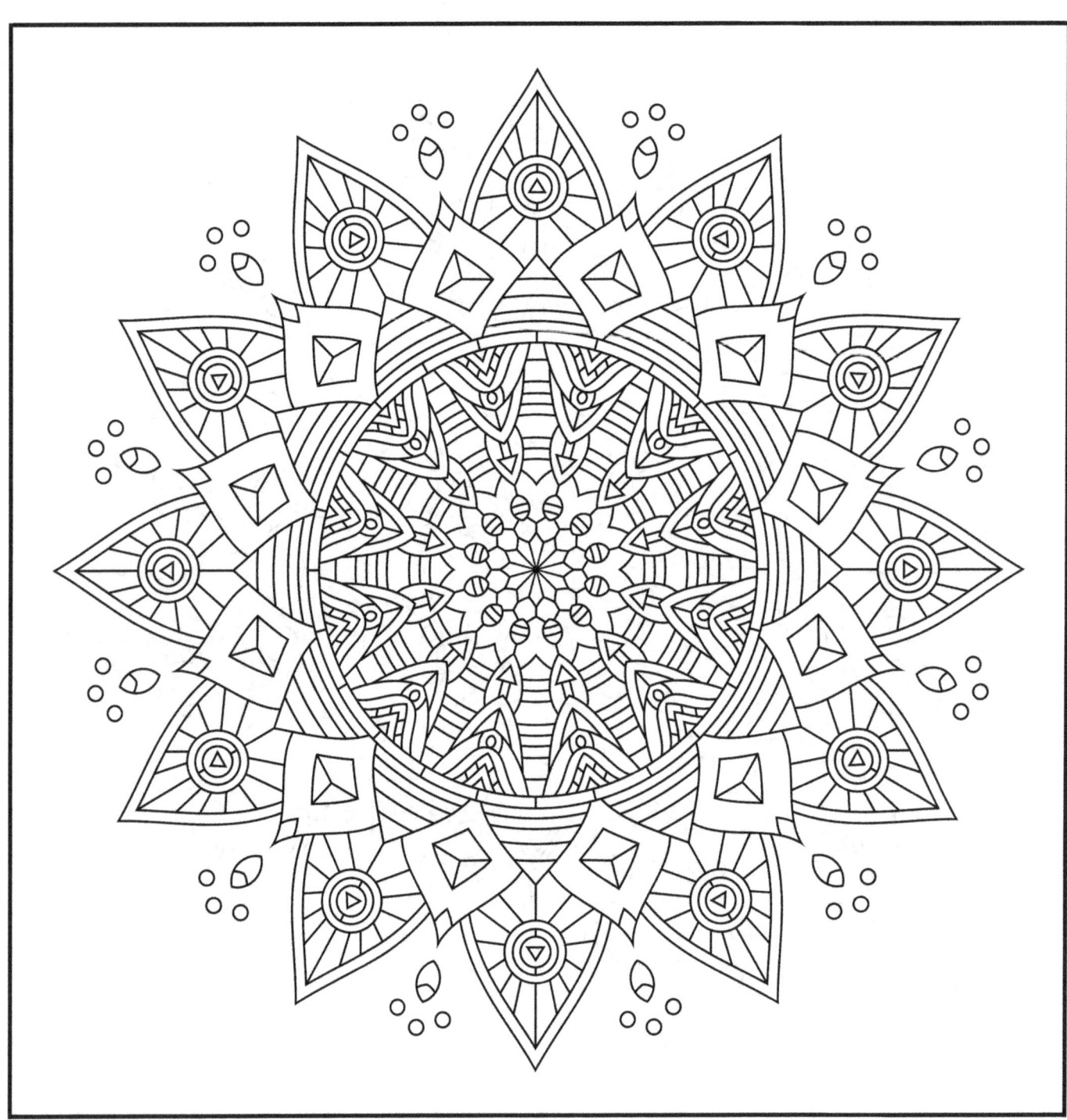

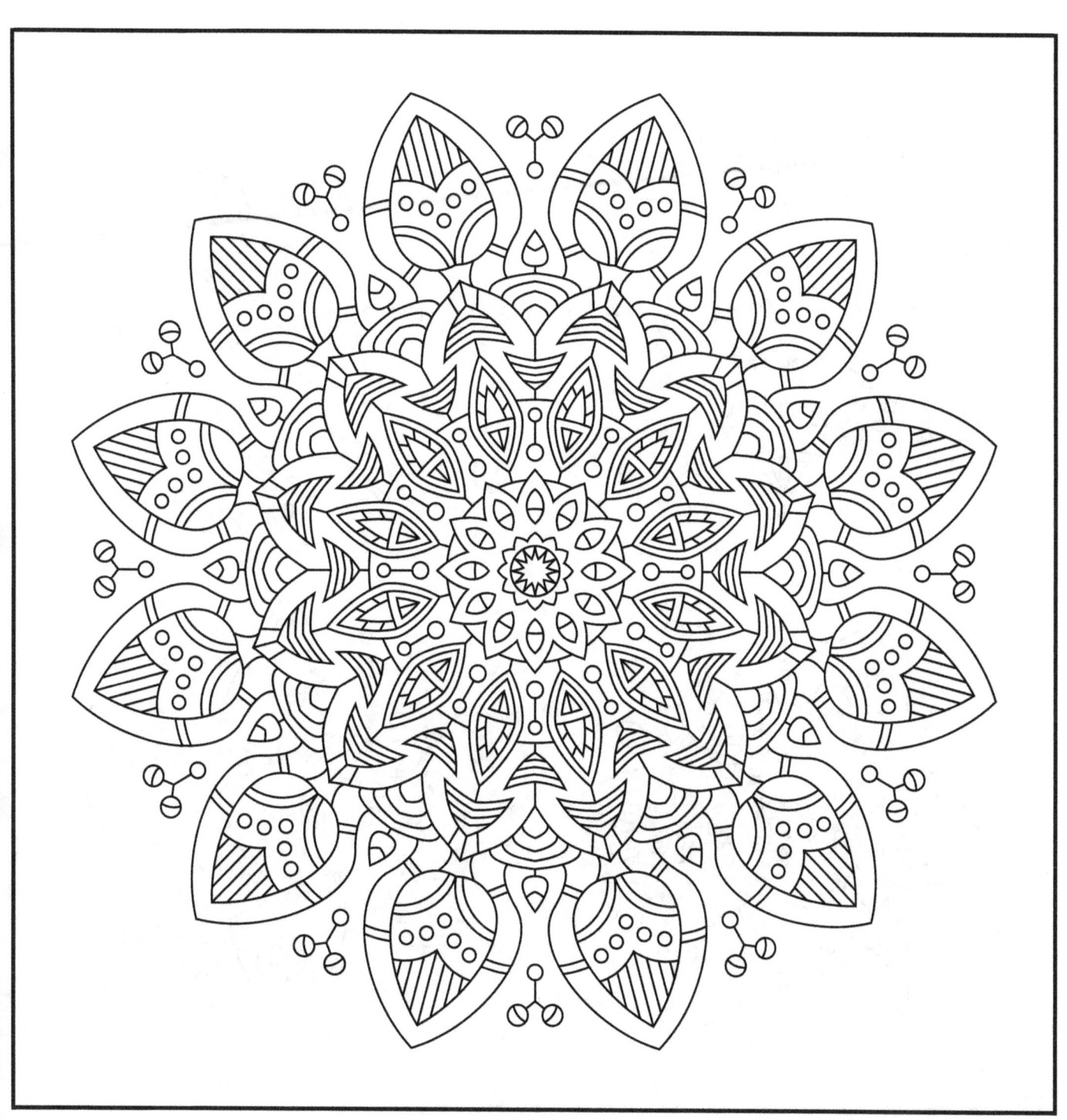

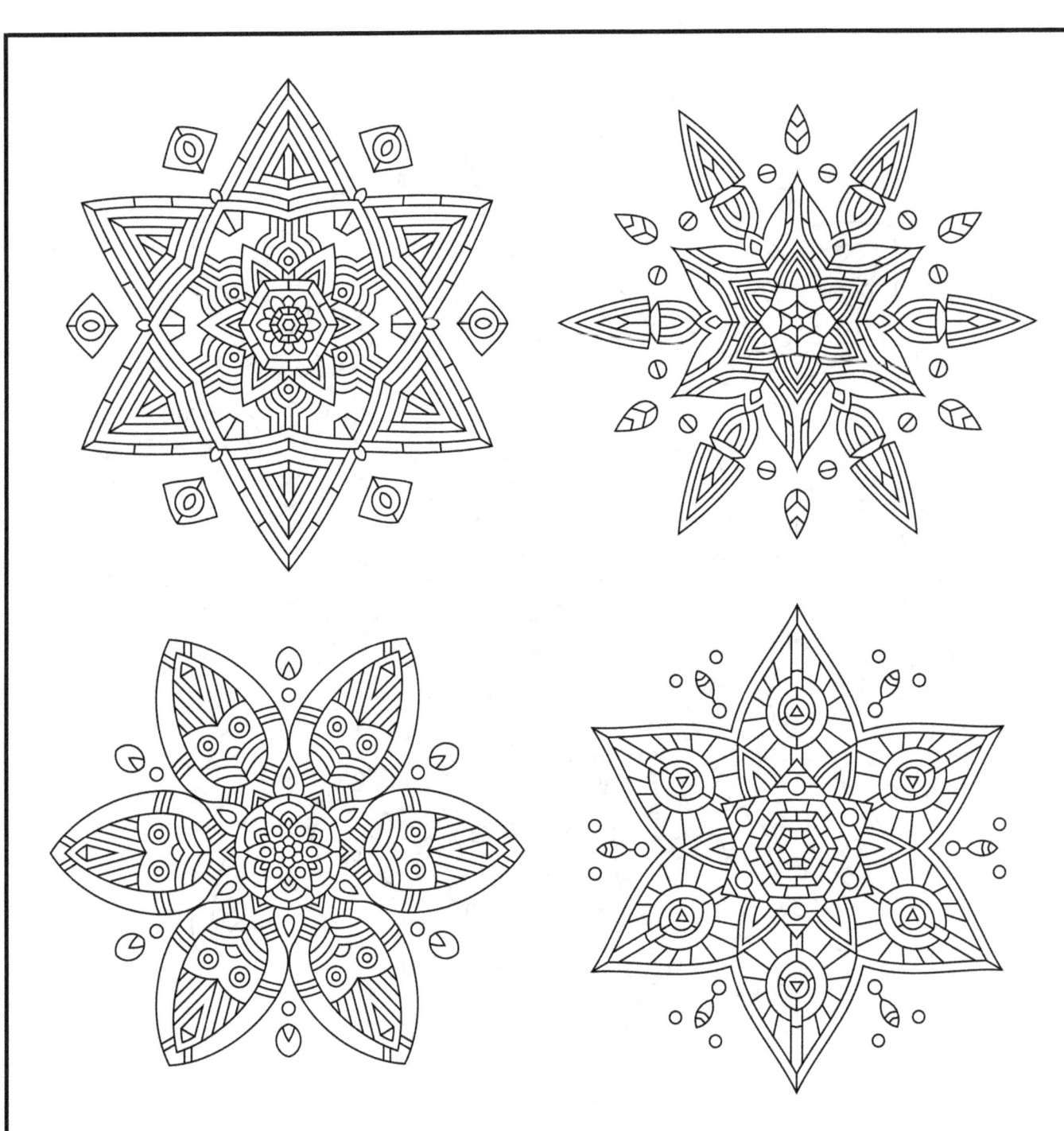

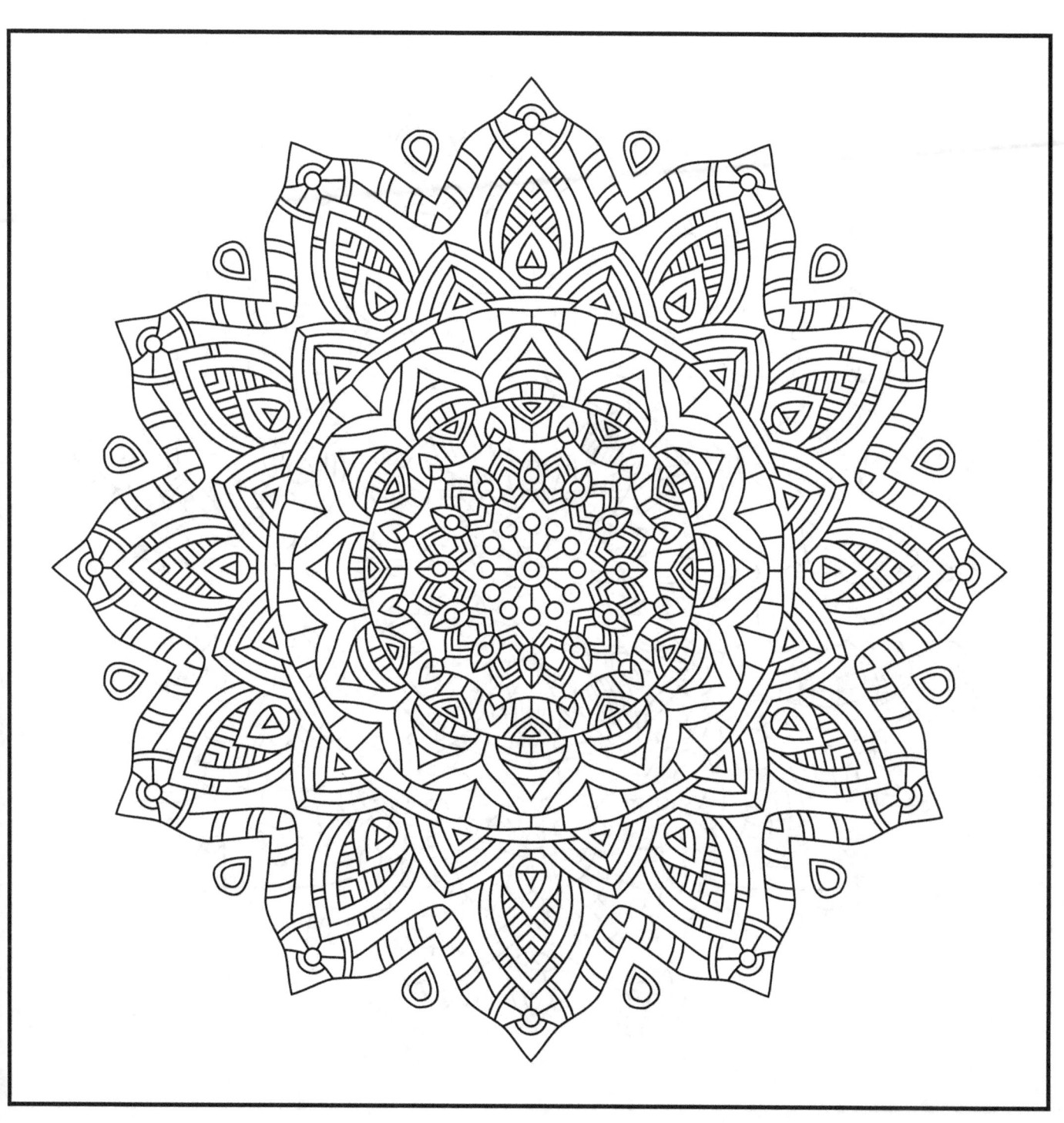

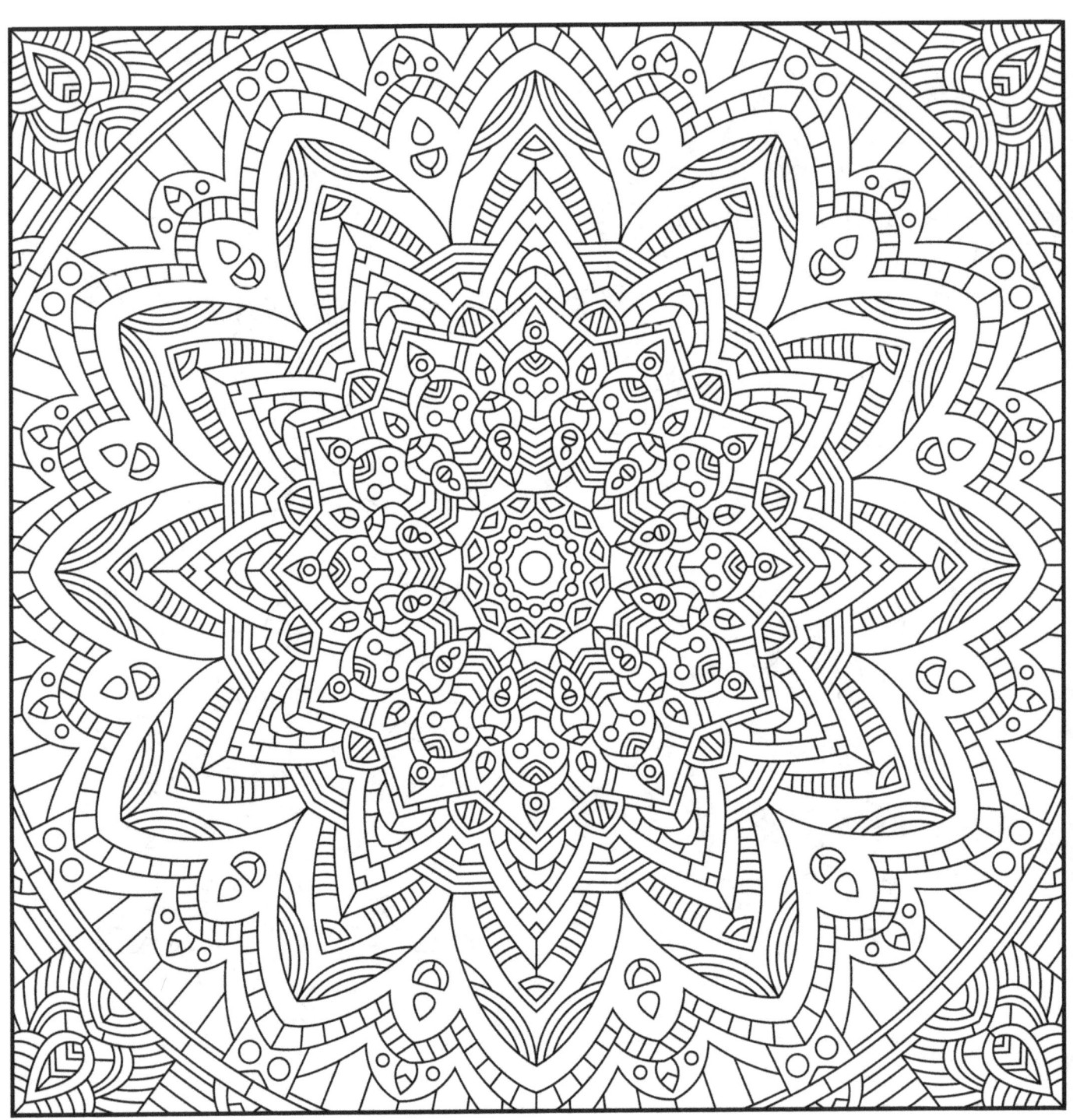

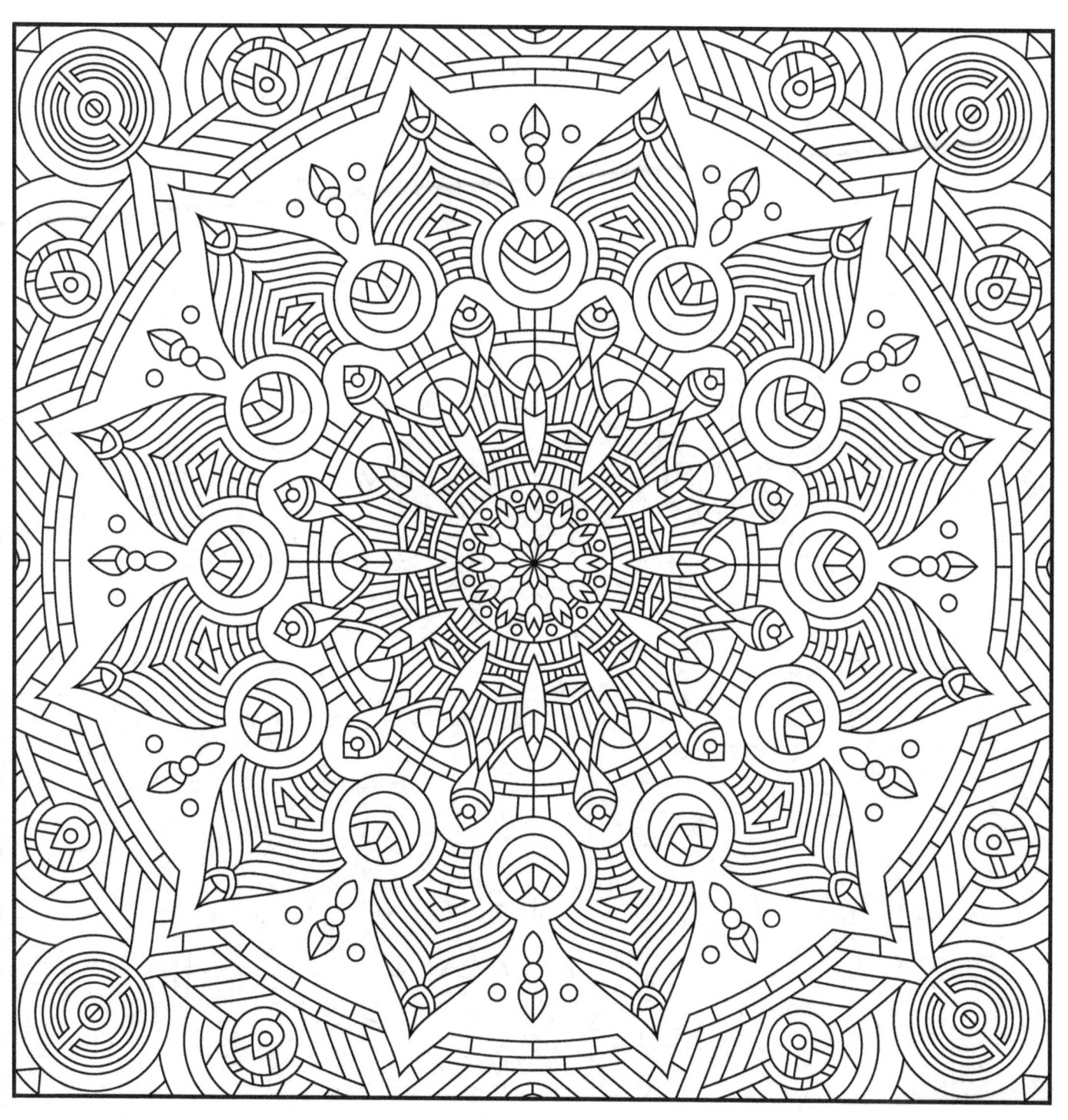

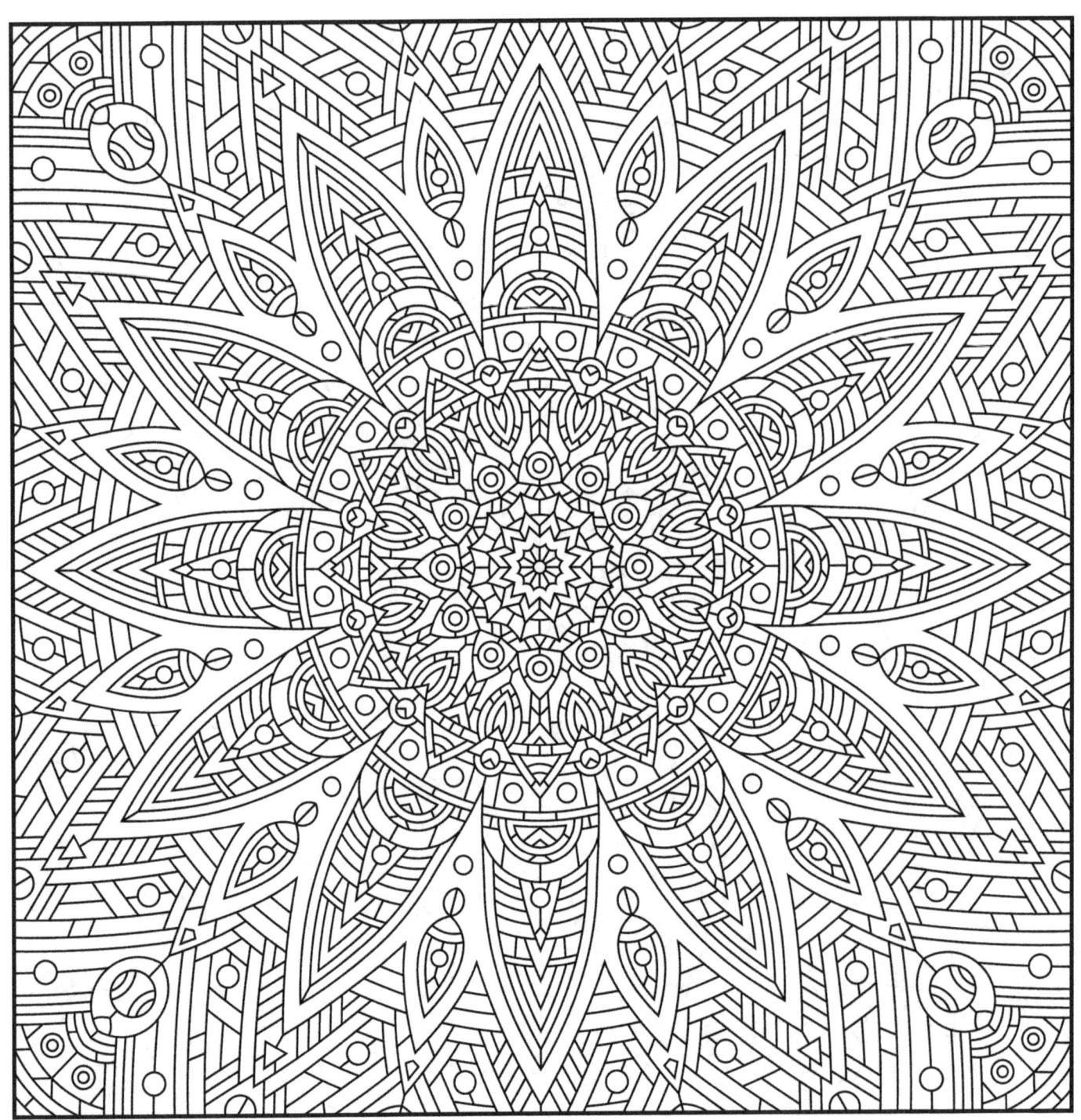

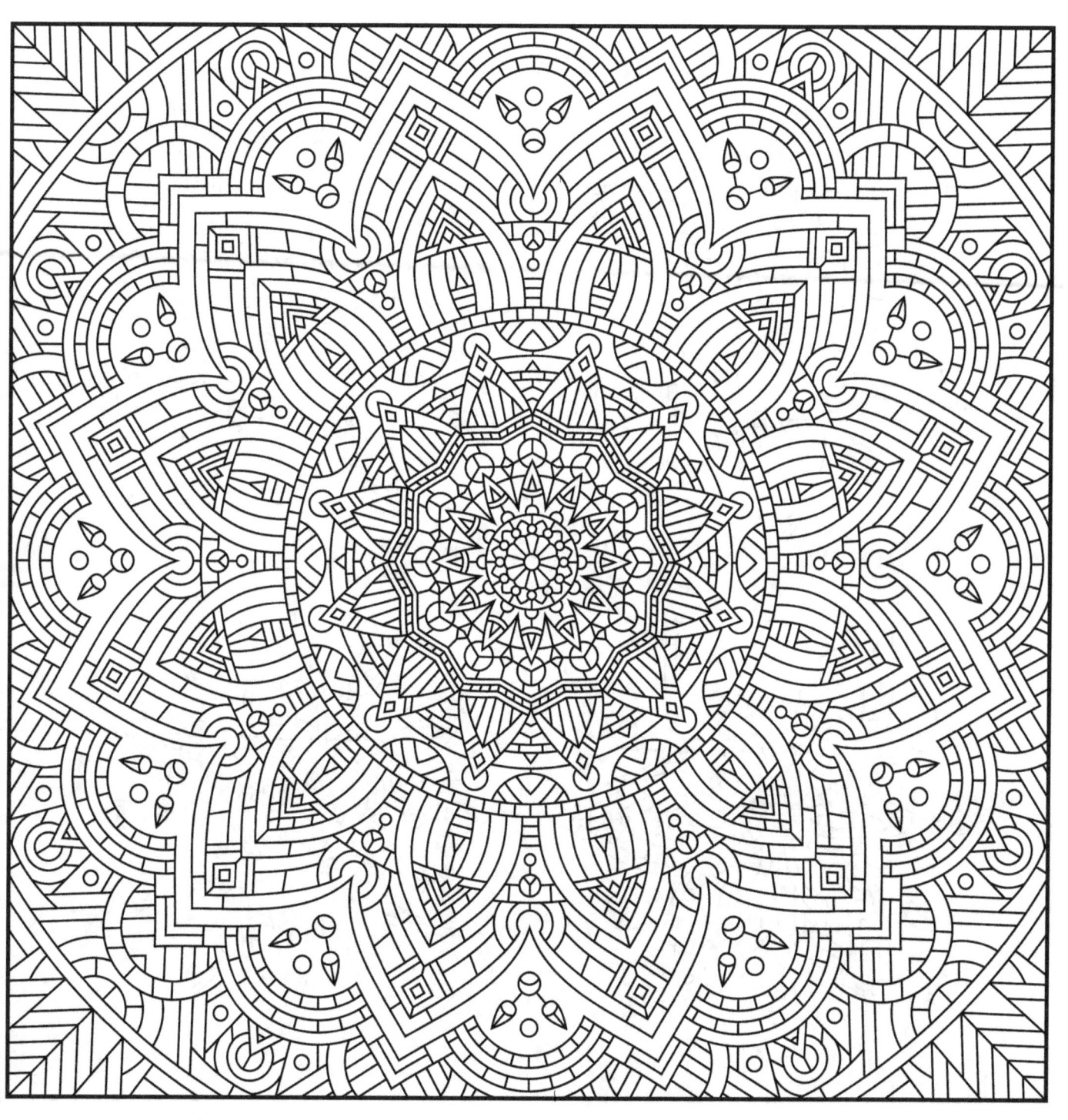

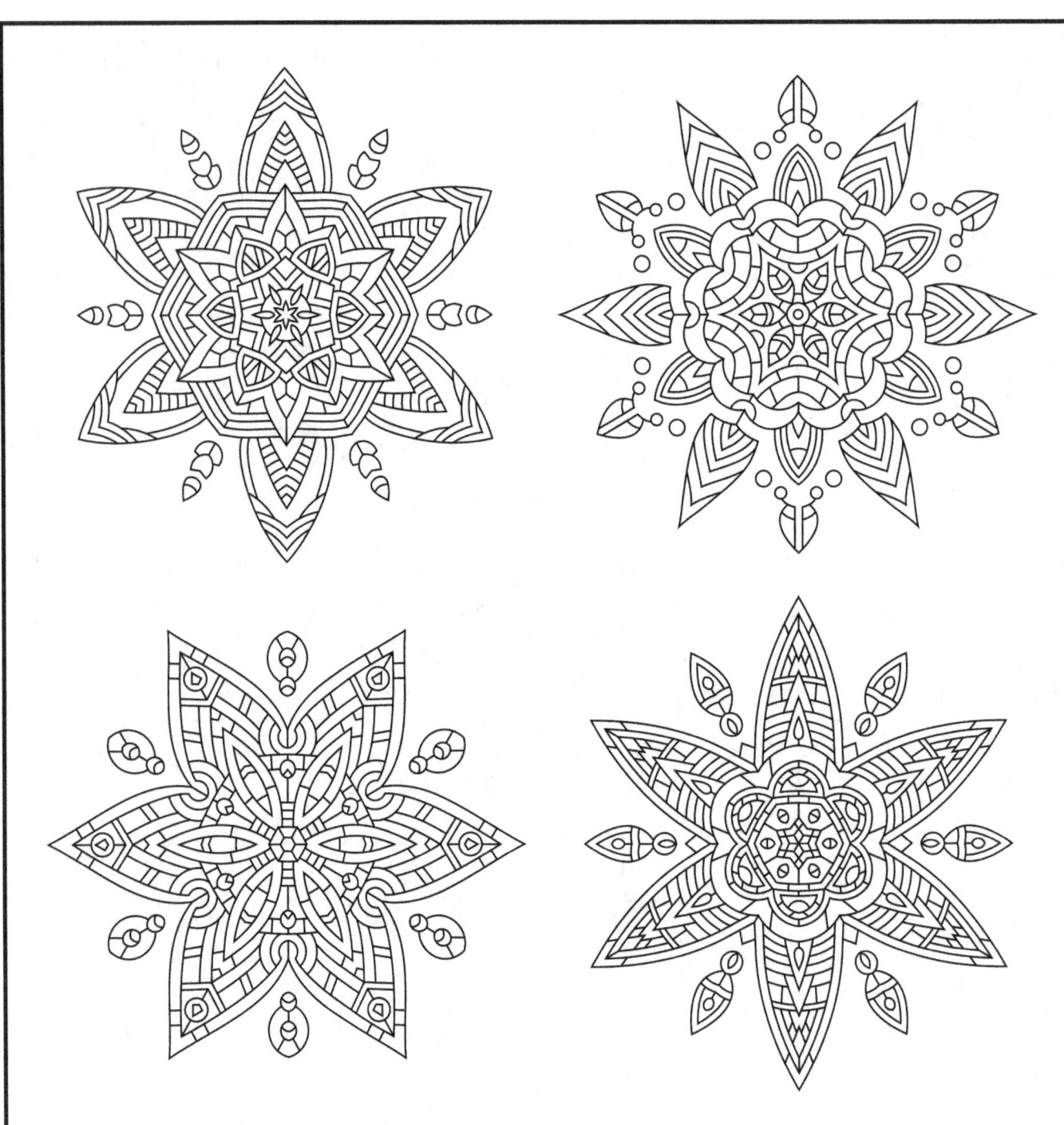

www.ingramcontent.com/pod-product-compliance
Lightning Source LLC
Chambersburg PA
CBHW081020170526
45158CB00010B/3113